LANDSCAPES

& Legacies

Parks, Natural Areas and Historic Sites of Newfoundland and Labrador

BY KEVIN REDMOND

St. John's, Newfoundland and Labrador, 2004

CREATIVE PUBLISHERS

Le Conseil des Arts | The Canada Council
du Canada | for the Arts

We acknowledge the support of The Canada Council for the Arts for our
publishing program.

We acknowledge the financial support of the Government of Canada through the Book
Publishing Industry Development Program (BPIDP) for our
publishing program.

∞ Printed on acid-free paper

Published by
CREATIVE PUBLISHERS
an imprint of CREATIVE BOOK PUBLISHING
a Transcontinental associated company
P.O. Box 8660, St. John's, Newfoundland and Labrador A1B 3T7

First Edition
Typeset in 11 point Goudy

Printed in Canada by:
TRANSCONTINENTAL

National Library of Canada Cataloguing in Publication

Redmond, Kevin, 1956

The Rose

By: Marjorie (Redmond) Costin

My mother always loved roses. Every time she went for a walk she came home with a wild rose to put in a vase. The rose became a symbol of simple pleasure, fragrance and beauty in our home. Little did I understand the significance of the "rose" for my mother, until I was diagnosed with breast cancer.

My mother was fifty when she had breast cancer. She is now eighty-eight and doing well. She walked to the General Hospital every day for her radiation, cobalt treatment, and on her way she passed a rose garden and picked a rose. She had been praying to St. Therese, The Little Flower, to help her through her sickness. The prayer says, "Please pick for me a rose from the heavenly gardens and send it to me as a message of love."

When I was diagnosed with cancer in November, my mother said she would pray to St. Therese for me to help me through the surgery and subsequent treatments. I had my surgery on November 23rd, in Saint John, New Brunswick.

Meanwhile, back in St. John's, Newfoundland, winter had come early and the ground was covered with a thick blanket of snow. On my mother's back deck, all of her flowers were dead including a potted rose bush. On November 24th, the day after my surgery, with the snow all around, the rose bush bloomed! One perfect rose that kept blooming amid the snow for a week! The "rose" was a very powerful symbol that profoundly moved my mother, me, and my family. Along with cancer, I share my mother's name, birthday and talent for music. The "rose," for me, has become my symbol of hope and healing.

I chose to give my medical oncologist a rose for every treatment because he is a very important part of that hope and healing. I also realize, in his profession, with the disease he treats, there must be a wide range of emotions that cover both ends of the spectrum. I understand this also because I lost my father to inoperable brain cancer. I wanted to share this with him because I have such a strong feeling that my story will have a good ending and I will enjoy a complete recovery. After all, I have to at least match my mother at eight-eight!

This summer, with lots of my husband's help, we will be planting a new rose garden. This garden will be a tribute to my mother as well as me. It is only through my own experience with cancer that I can truly understand what my mother went through thirty-eight years ago. Our rose garden will be a place to sit and reflect, and enjoy the simple pleasures, fragrance and beauty of the "rose."

Dedication

To those who,
through challenges of adversity,
rise in spirit,
offering others
peace, love and hope.

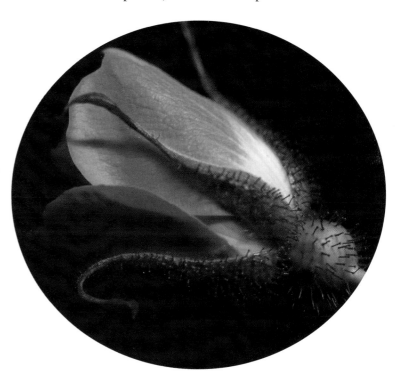

"Prosperity makes friends, adversity tries them."
– Publius Syrus

Acknowledgements

In compiling Landscapes & Legacies there are numerous people and organizations that have assisted me and deserving of thanks!

To: my wife Sophia for your support and encouragement.

To: my children Thomas, Susan and Jacquelyn whose willingness to explore will always be treasured and your patience while "dad takes **another** picture" always appreciated.

To: all those along the way that were gracious and willing to be photographed, especially Lloyd Pike, David Dick, Pat Dornan, Thomas Redmond, Susan Redmond and Jacquelyn Redmond.

To: all fellow explorers who have graced me with their presence especially Pat Dornan whose hawk-like eyes frequently beckoned my camera. Dan Murphy whose wealth of knowledge has a way of succinctly putting things in their proper perspective, Eric West whose musical talent add a transcendental dimension to our adventure travels.

To: Jon and Judy Lien who embody only the best of altruistic motives touching all with their knowledge, kindness and generosity.

To: Parks Canada East Coast Field Unit, Corner Brook Economic Development Corporation and Provincial Parks and Natural Areas Division of the Department of Tourism, Culture & Recreation; your logistical support and financial contributions allowed me to photograph freely your special areas and give them the attention they rightfully deserve.

The Newfoundland Museum and its staff who provided artifacts (on pages 13, bottom right; page 34, right; page 53, bottom right); Department of Mines and Energy who provided fossils (page 29, right; page 36, left); to artists Gilbert Hay (page 11) and William Ritchie (page 32) who allowed their work to be photographed by the author; and to publishers McGill-Queens University Press (Lives and Landscapes) and Breakwater Books (Voyages) for permission to use quotes on pages 32 and 48 respectively.

To: the many special experts who assisted with this book: Julianna Coffey, Bill Brake, Jewel Cunningham, David Taylor, David Lough, Jeremy Roop, Andrea Côte, Cyril Bambrick, Mike Rose, Leah Feltham, Rob Hingston, Fred Sheppard, Fyzee Shuhood, Sian French, Bert Hillier, Dennis Tilley, Elizabeth Smith, Doug Boyce, Elaine Anton, Kevin McAleese, Mark Sexton, Ali Johnston, Randy Edmunds, William Ritchie, Gordon Slade, Kirby Pye, Darlene Scott, Lucy O'Driscoll, Jim Lyall, Kit Ward, Colleen Sutton, and T.A. Loeffler.

To: Dawn Roche who readily accepted the original concept; Dwayne Lafitte of Creative Book Publishers who did it all in putting together such a fine product. His consideration, patience and expertise made the process both rewarding and enjoyable; Jason Tucker, Donna Francis, Bill Spurvey, Dave Peckford and Angela Pitcher for your help and expertise in the completion of the final product; and Steve Bartlett for the author photo.

To: Mom ... your zest for love & life is not lost in our passion for living life to the fullest.

Parks Canada
Parcs Canada

Parks & Natural Areas
Newfoundland & Labrador

CORNER BROOK
Our Spirit...Your Success

TABLE OF CONTENTS

* All "National Parks, Historic Sites/Districts" are "of Canada"

INTRODUCTION

"The finest workers in stone are not copper or steel tools, but the gentle touches of air and water working at their leisure with a liberal allowance of time."

-Henry David Thoreau

Newfoundland and Labrador as we know it today is the culmination of human habitation for approximately 9,000 years and well over a billion years of geological metamorphosis.

Through successive continental plate collision and breakup our world has evolved from the modern world's continents being connected, to what we know today. Most of Labrador is geologically very old, having passed through at least two cycles of ancient crustal plates colliding (mountain building) and then drifting apart. Today, Labrador represents the easternmost extension of the great Canadian Shield with the origin of its Torngat Mountains being the oldest rocks known, dated at 3.7 billion years.

Like Labrador, insular Newfoundland is geologically unique, but for different reasons. Simplistically, it is divided into three geological zones, western, central and eastern, each with notably distinct origins. The western zone (northern peninsula extended south) has been a part of North America for over a billion years whereas the other two zones are relative newcomers. The central zone (east of White Bay to west of Avalon Peninsula) was formed by an earlier continental plate collision while the eastern zone (roughly just west of and including the Avalon Peninsula) was once a part of Europe. As the theory of plate tectonics was being developed in the mid 1960s, insular Newfoundland's geology came under intense international

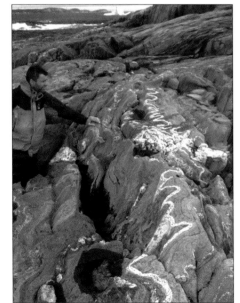

Geological folding, Battle Harbour.

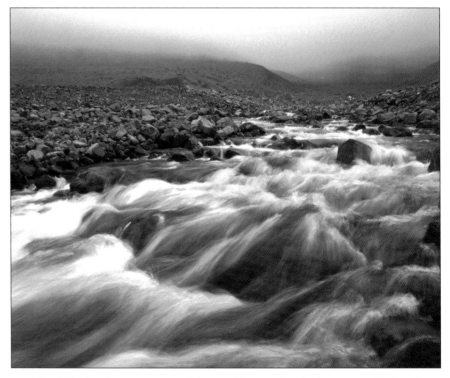

The Tablelands expose part of the earth's mantle which is normally found 3-4 kms beneath the earth's surface.

scrutiny and served an important role in supporting the currently accepted theory of plate tectonics.

Among some of the natural phenomena revealed through geological evolution are some of the oldest fossils (such as Green Point and Mistaken Point) in the world and the exposure of the earth's mantle in Gros Morne National Park. This is one of the few places in the world where the earth's mantle can be viewed on the earth's surface and a key reason for the park's UNESCO world heritage site designation. Through all of the blending and upheaval Newfoundland and Labrador is a geologist and paleontologist playground.

Up until some 10,000 years ago Newfoundland and Labrador, excluding the Codroy Valley area, was covered by Glaciers. As they receded, relieved of the glacier's weight, in places evidence of the earth's rebound is manifest. The coastal lowland plain west of the Long Range Mountains on the Northern Peninsula was an ocean bed before rebounding above the present day sea level. Along southern Labrador ancient ocean beach heads are now hundreds of metres above sea level.

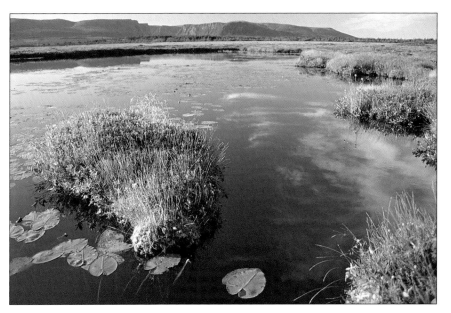

Coastal Lowland Plain (was once an ancient seabed).

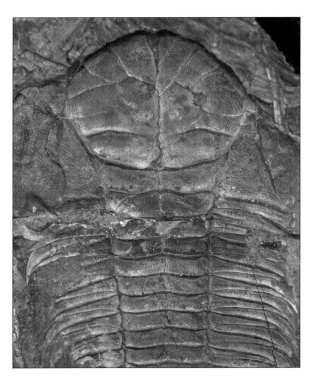

A very well defined 400 million-year-old Trilobite, measuring approximately 20 cm (8 in) in height.

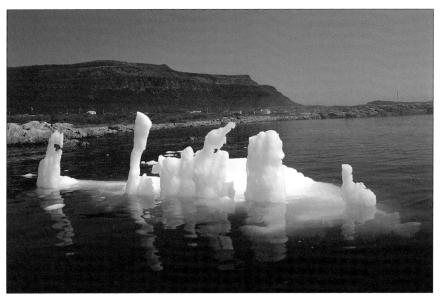

Raised beach heads evidenced in centre and top right corners of hillside.

Human History

Human history time lines are minuscule compared to geological events. Yet, the culmination of geological events laid the foundation for a multitude of rich multi-faceted terrestrial and marine ecosystems. The retreat of glaciers ceded access to the riches of the land and the sea to ancient cultures. Although land based resources such as caribou have been an integral survival component for most cultures, it is the water based resources and primarily those of the sea, that have been the most substantial reason for being here. The coastline of Newfoundland and Labrador is its greatest virtue. Eventually, whether on its own or through the circle of life, most everything eventually makes its way to the coast. Rivers are the obvious terrestrial gateways to the coast. Currents, rivers of the ocean, combine with the moon's gravitational pull and resultant ocean tides are ultimately drawn to a coastline. At the coastline is a merging of ecosystems and life forms. Coastal sites yield exploitable access to both terrestrial and marine resources; hence, the strong historical coastal occupational prevalence by aboriginal, ancestral and modern cultures.

Man can survive weeks without food but only days without water. Therefore, it is not surprising that many archeological sites and recent settlements are positioned near a suitable source of freshwater.

The earliest traces of human activity in Labrador date back approximately 9,000 years. Evidence of the first Maritime Archaic Tradition sites were found twenty-five to thirty metres above sea level and about one kilometer inland on the Strait of Belle Isle coast of Southern Labrador. It is believed that these were once sea shore campsites, the difference being caused by the earth's rebound after glacial recession.

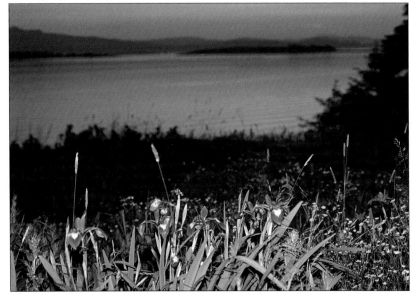

Pinware river valley. Adjacent to earliest traces of human activity in Labrador.

Pollination.

Butterfly caught in a web. The circle of life.

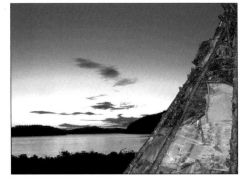

The Beaches. Site of earliest traces of human activity on the island of Newfoundland.

The earliest traces of human activity on insular Newfoundland date back close to 4,000 years ago occurring at The Beaches site. The Beaches, like many archeological sites throughout Newfoundland and Labrador reveal occupation by multiple cultures. There appears to be minimal overlap or concurrent occupation and few clues as to why these early cultures vanished when they did.

These earliest inhabitants were followed by early Paleo-Eskimo (~3,800-3,200 BP*), Dorset Eskimo (~3,000- ,400 BP), Recent Indian (~1,900 BP - present) and Thule/ Labrador Eskimo (~1,500 A.D. to present). *Before Present

The earliest Europeans to arrive in the "New World" were the Norse, arriving around 1,000 A.D. and occupying the L'Anse aux Meadows site

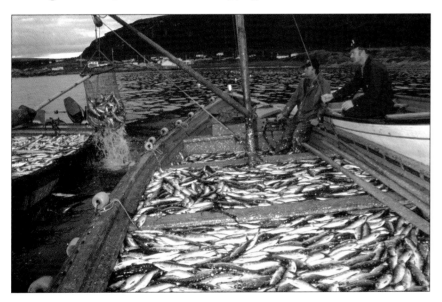

Traditional inshore fishery of days gone by.

for a mere fifteen years. John Cabot's arrival in 1497 reflects the genesis of modern day European settlement. In the early years permanent settlement was forbidden by law as it was felt the settlers would be in competition with British merchants. Newfoundland was a giant European fishing station.

Colonization saw both English and French settlements. Eventual conflict resulted in numerous battles and three famous treaties that affected Newfoundland and Labrador's history. The Treaty of Utrecht (1713 A.D.) forced France to relinquish all sovereign territorial claims in exchange for territorial fishing rights from Cape Bonavista north to the tip of the Northern Peninsula and south to Point Riche. French subjects were to leave or become British subjects. Many left for Cape Breton or St. Pierre. Successive treaties, Paris (1763) and Versailles (1783) further defined (or limited) French fishing rights and territories with the British eventually taking full control of the territory as we know it today.

The racial extinction of the Beothuk Indians in the early 1800s is another example of cross cultural conflict over resources gone wrong. "Bloody Reach" and "Bloody Point" are not incorrectly named and are poignant reminders of culturally significant historical events.

In most cases, defining cultural events represent transition and change usually for some simple goal of ease and/or efficiency. When the "hunter and gatherer" cultures learned to farm the resultant lifestyle change was a significant deviation from a long standing tradition. A number of recent cultural changes remain ripe

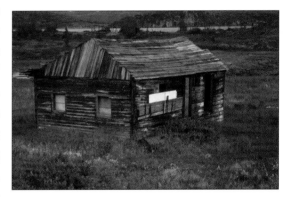

Remnants of Resettlement.

in minds of most Newfoundlanders and Labradorians. One is the transition of the northern Inuit from a traditional nomadic hunter and gatherer lifestyle to the modern community based settlement. A second more recent cultural change was the government initiated resettlement program of the 1960's, which saw many rural, isolated communities shut down, moving its residents to larger centers. Both of these events, though grieving

most of those affected, add nostalgia to the experience of those who return and rediscover some of the traditional virtues of times long gone. Here, contextual historical appreciation expands the mind and touches the heart, conceiving profound personal lifelong experiential moments.

"If a man look sharply and attentively, he shall see Fortune; for though she is blind, she is not invisible."

Francis Bacon

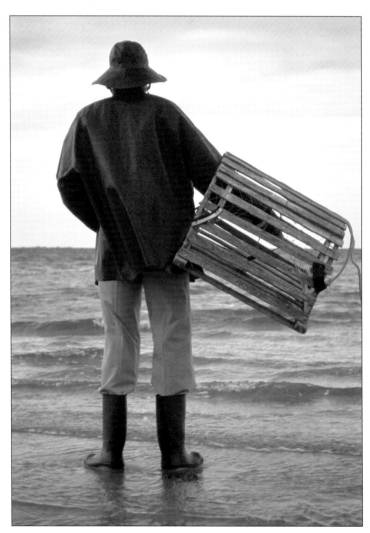

Fisherman looking to sea, wondering what tomorrow will bring.

Perhaps the biggest cultural change affecting Newfoundland and Labrador's history is not the silicon chip, but the decline of the commercial cod fishery. For close to 500 years the fishery in Newfoundland and Labrador was an integral part of most peoples lives and had survived numerous evolutionary changes. For example, the invention of refrigeration in the early 1950's led to the collapse of the salt fish trade but demand for fresh frozen fish sustained the industry. In some remote isolated communities that lacked electricity, winter ice was cut in blocks and stored in sawdust until needed in summer. In 1992, after years of government mismanagement and modern technology surpassing its usefulness, the Atlantic Cod was declared an endangered species, and the cod fishery as we know it remains closed to this day. Today Fisherfolk look to the ocean wondering what tomorrow will bring?

Natural History

"Art is man's nature; nature is God's art."

Philip James Bailey

Why all the Fish and why the big deal about Fish?

The Labrador current collides with the Gulf Stream of Mexico over the continental shelf just off insular Newfoundland's east coast. Commonly referred to as the Grand Banks these internationally renowned fishing grounds have traditionally yielded rich Fish stocks and attracted fishing fleets from around the world. When John Cabot arrived in 1497 he described them as "being so thick you just had to dip your basket in the water and it would come up full of Fish."

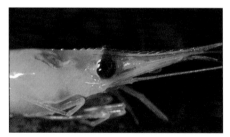

Shrimp, one link in the food chain.

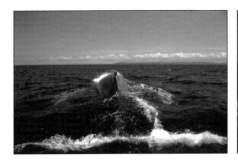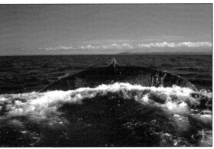

Not much privacy here: A rare sighting of a humpback whale having a poo.

Fish like moving water. In a freshwater lake the most common place to find Fish is the run-in or run-out. Here at the run-in and run-out, currents bring the food to the Fish. Similarly, on the Grand Banks, the cold Labrador current converges with the warm Gulf Stream. These two converging nutrient rich currents, are further funneled by the shallow banks of the continental shelf, creating conditions where Codfish and numerous other species thrive, thereby spawning a huge food source attracting a wide variety of marine species. All these marine species contribute significantly to defining Newfoundland and

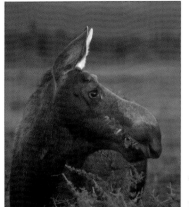

Labrador today and support some of the largest bird rookeries in the world; such as Witless Bay Ecological Reserve, attracting the largest summer concentration of Humpback Whales in the world.

Fourteen species of indigenous animals are found on insular Newfoundland and twenty seven in Labrador. Northern Labrador offers sanctuary to the world's largest Caribou herd, the George River herd, numbering somewhere between 500,000 and 700,000 animals. Although not native to Newfoundland, Moose have adapted extremely well. Gros Morne National Park is recognized by some for having the highest density of moose in the world.

There are a total of nineteen ecoregions found in Newfoundland and Labrador, ten in Labrador and nine in Newfoundland. Together they represent a diverse arrangement of conditions suitable for supporting a correlating range

The Moose – 1 pair unsuccessfully introduced to the province in 1878, 2 pairs successfully introduced on May 14, 1904. Today's Moose population exceeds 100,000 with some world renown population pockets such as in Gros Morne National Park.

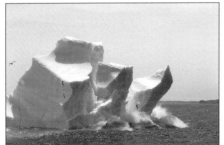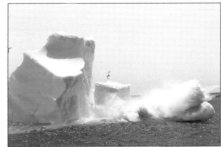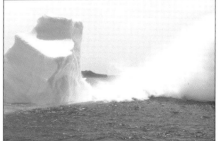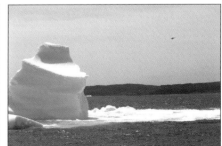

A good reason for keeping your distance from an iceberg. They founder in seconds without notice.

of plant life. In some cases local micro-climates and conditions further enrich or restrict flora and fauna growth, creating a unique and distinguished anomaly. In all, Newfoundland and Labrador feature 1,034 known indigenous plant species ... more than you will find on any "walk in the park."

Finally, the province's abundant natural history is capped off by a seemingly endless parade of arctic pack ice and icebergs. Arctic pack ice frequently includes seals and sometimes a vagrant polar bear. Insular Newfoundland represents the most southerly and accessible site in eastern North America for viewing icebergs. Calved from Greenland glaciers, these icebergs complete their three year journey south off the coast of Newfoundland and Labrador.

The parks, natural areas and reserves included in this book are designated primarily because of their rich natural history and may be augmented with local cultural history. Whereas the primary attribute of designated Historic Sites is their cultural significance, possibly supplemented by natural history. Together they represent a composite reflection of our past and present, natural and human qualities.

Not every designated park, reserve, natural area or historical site is included in this book. Nor are the associated text and images intended to be a complete documentation of each site. A book could be easily written on each site. The intention of this book is to share some of the special places throughout Newfoundland and Labrador. It is hoped that this book will be a keepsake of some of the special places you have been fortunate enough to experience and an alluring catalyst to new sites you may wish to explore. Special places usually facilitate memories of a positive experience, a feeling of "being there!" Such memories and the feelings attached to them are a light load to carry, capable of brightening our lives long after the experience. When the experience expands the mind and touches the heart, it becomes a part of the individual's value system, making it in effect a life long experience. Hence, Newfoundland and Labrador ... The Heart Land!

"A mind that is stretched by a new experience can never go back to its old dimension."

Oliver Wendall Holmes

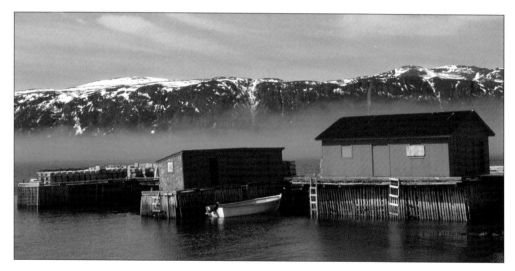

Early morning, radiant fog, Bonne Bay.

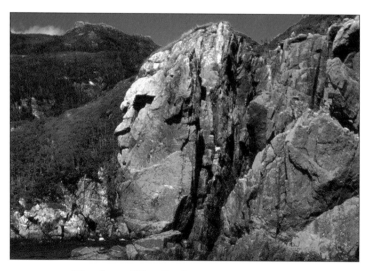

The face of Bay Du Loup, east of Burgeo.

"They say Labrador is the land that God gave to Cain. Because of this most people who don't know Labrador think that it is a harsh and desolate place. We Labradorians know that Cain hit the jackpot."

Bill Edmunds

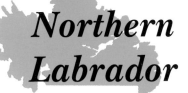

Northern Labrador

Today Northern Labrador manifests a convergence of historic and current affairs. A landscape defined largely by the retreat of the Laurentide glacier from Labrador some 10,000 years ago; glacial erratics, valleys, fjords, lakes and rivers litter the land amongst some of the largest mountains in eastern North America. The "big land" still reveals tantalizing scraps of evidence of a nomadic aboriginal lifestyle in the midst of a rich medley of natural history.

Natural resources such as the George River Caribou Herd (the world's largest) and Ramah Chert attracted aboriginal groups to northern Labrador. Chert, a fine-grained stone composed mainly of silica was the preferred stone for tool making among pre historic cultures. The stone was brittle, fractured with a sharp edge and stone workers could predict the pattern with which the chert fractured, thereby producing a better tool. Cape Mugford and Ramah Bay are the only two known quality sources of flakeable chert along the entire Labrador coast, yet the chert has been found as far south as Maine and west to Trois Riviéres. A modern day version of chert's historic economic value has been likened to the nickel and copper deposit recently discovered in Voisey's Bay.

The influence of European cultures is all too obvious in the small isolated communities along the coast. One European group that had a strong influence on Northern Labrador was the Moravian Mission

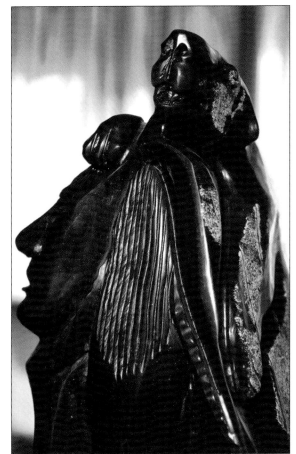

Soapstone carving by Gilbert Hay of Nain.

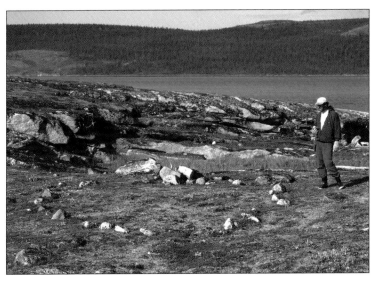

Tent Ring (circle of rocks).
Remnants of the traditional aboriginal nomadic lifestyle.

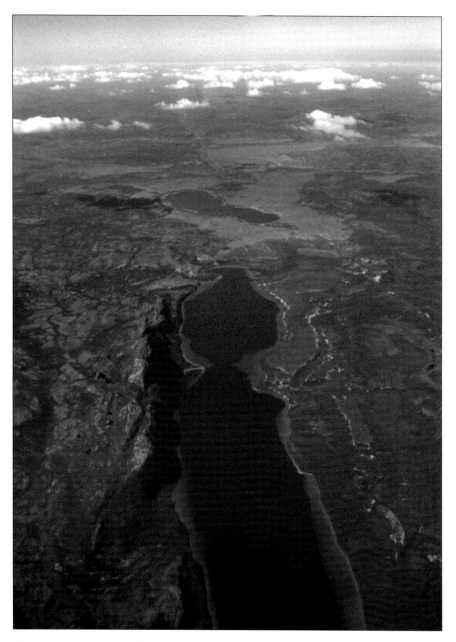

which sprang out of the missions in Greenland and sent their first missionaries to Labrador in 1752. In 1770 King George III granted the Moravian's their choice of one hundred thousand acres of the Labrador coast. Aboriginal contact with the outside world was sometimes catastrophic. In 1918 supply ships to Labrador carrying the Spanish Flu lead to the death of one third of the Inuit population, originally only 1,200 strong.

The closing and resettlement of Nutak and Hebron Moravian missions in 1959 made Nain the northernmost community in Labrador.

Icelandic poppies brought to Labrador by the Moravian Missionaries

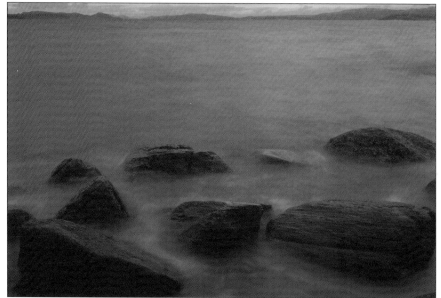

Northern Labrador, a glacially carved landscape featuring some of the oldest rock found on Earth, dating 3.7 billion years old.

Looking out from our campsite one early morning in Voisey's Bay. Here we caught arctic char while seals and minke whales fed and frolicked just metres from shore.

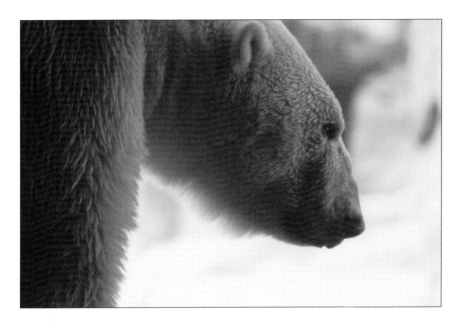

Travelling here you must be prepared for all that nature has to offer. In recent years a Polar Bear chased a group of sea kayakers, forcing them to retreat kilometers back to their last campsite. In the Mugfords a hiking guide was forced to shoot a Polar Bear that ambled into the campsite. Before travelling in this area, it is recommended to check in with the Labrador Inuit Association.

The opening of the new national Park in the Torngat Mountains and the added development associated with Voisey's Bay Nickel Mine will naturally result in increased tourism in the area.

←—— The Polar Bear remains today a sacred animal to the Inuit. It is well adapted to life in the North. With two layers of fur and 4-5 cms of insulating blubber, activity is restricted to avoid overheating, even in extreme cold temperatures.

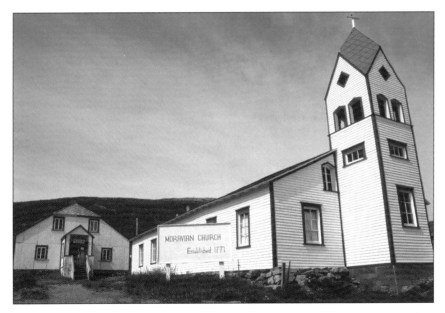

This church located in Nain, dates back to the early 1900s. Like most of the Moravian buildings, it was pre-fabricated in Europe, shipped in pieces and assembled on site.

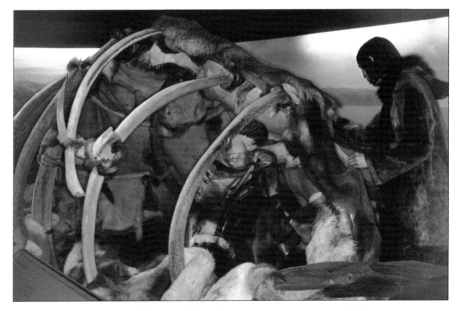

Cross-sectional view of Thule (~750 BP) encampment made of Whale bone, Seal and Caribou hide.

Battle Harbour National Historic District

For close to two centuries, Battle Harbour was known as the "Capital of Labrador." It was the economic and social centre of the southeastern Labrador coast.

Ideally located for the cod and seal fisheries, the establishment of the John Slade and Co. mercantile salt-fish premises in 1770 became the basis of a permanent community. After 100 years of operation, in 1955, the Slades sold their business interest in Battle Harbour. The level of activity at Battle Harbour resulted in all major social institutions, including legal, religious, health, educational, Canadian Marconi, the Newfoundland Ranger Force and after confederation, the Royal Canadian Mounted Police were represented in the community. The hospital established by Dr. Wilfred Grenfell in 1892 at Battle Harbour was the only hospital outside St. John's. Life in Battle Harbour throughout this time was typical of Newfoundland and Labrador's social structures, institutions and fisheries.

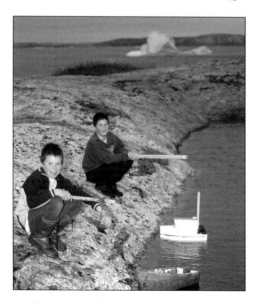

Summer residents of Battle Harbour.

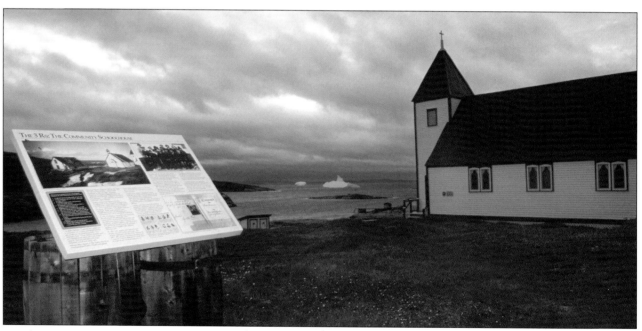

Church of St. James the Apostle, built in 1852 and restored in 1990.

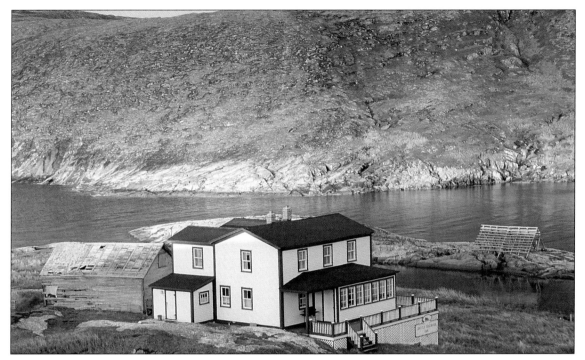

In 1955 the Earle Freighting Services Ltd. purchased the site and continued its operation until the decline in the inshore fishery at the start of the 1990s. At that time the site was donated to the Battle Harbour Historic Trust under whose direction the site was restored and is currently managed.

Today more than twenty historic buildings, stages, walkways and work areas have been restored. Noted ecclesiastical architect William Grey, designed Battle Harbour's Church of St. James the Apostle. Built in 1852 and restored in 1990, it is the sole surviving example of Grey's work as well as being the oldest surviving Anglican church in Newfoundland and Labrador.

← Battle Harbour Inn, once the merchant's home.

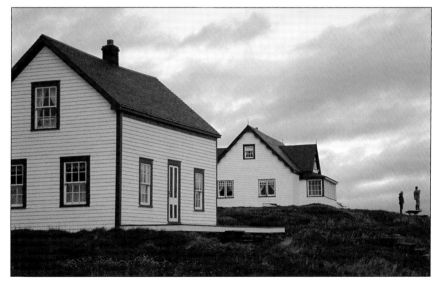

Isaac Smith's home (left). Grenfell Mission Cottage (right).

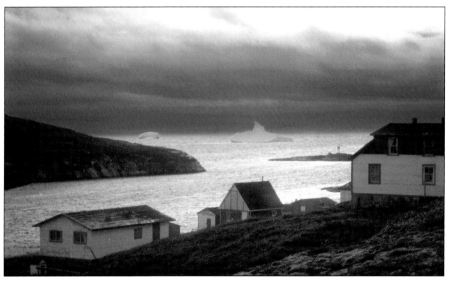

Two of 35 icebergs driven landwards by a North East gale.

Foyer of Battle Harbour Inn.

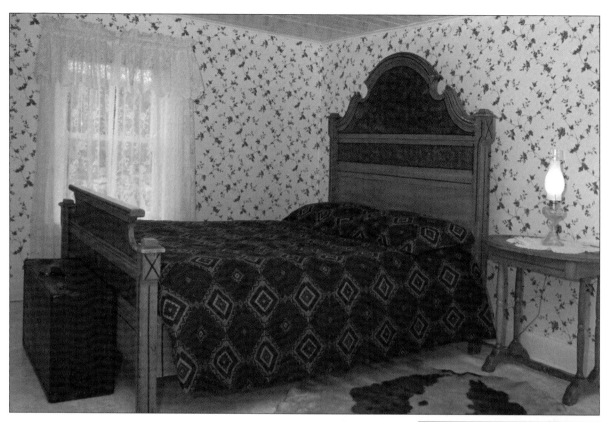

Accommodations of Battle Harbour Inn.

Hundreds of artifacts throughout the site aid in recreating a rich and poignant experience. The concave stairs leading to the loft of the salt shed is testament to the activity this place once witnessed. An added attraction is some of those who have ascended these steps, such as Commander Robert E. Peary who held two press conferences in the salt shed loft, touching off the debate between Peary and Cook as to who exactly had reached the Pole first ... a debate that continues to this very day.

Accommodations available include many of the restored heritage homes such as the Grenfel Mission doctor's cottage, cook house, bunk house and the Isaac Smith house, the oldest residential dwelling in southeastern Labrador. Modern amenities in a historically restored setting, Battle Harbour offers the best of both worlds.

The saltshed.

The worlds first oil boom occurred in Red Bay in the last half of the sixteenth century. Archeological excavations in 1978 revealed what has been recognized as Canada's first industrial complex.

Basque whalers from the Basque Provinces of France and Spain converged on the Strait of Belle Isle to hunt the Right and Bowhead Whales. Using the sheltered harbour of Red Bay as the base of operations, they processed whale blubber using sixteenth century oil refineries known as tryworks to render the blubber into marketable whale oil.

Discovered in the bottom of Red Bay harbour was a sixteenth century whale ship, believed to be the *San Juan*. The ship found is recognized as the best preserved example yet found of the type of vessel which the Europeans used to colonize the new world.

Red Bay National Historic Site

Typical dress of 16th century basque whalers.

Red Bay Harbour protected by Saddle Island (top). Note wreck of BERNIER *(bottom left of Saddle Island).* ⟶

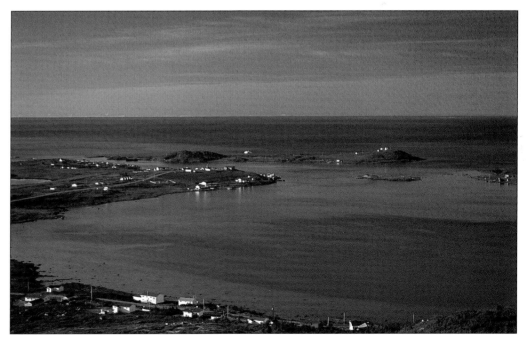

Saddle Island, site of the try-works also includes some sixty-graves, containing about 140 skeletons. Fragments of Basque ceramic tile still can be found along the shoreline in and around Red Bay.

Partridge berries.

The bakeapple or Norweigan cloud berry. A Labrador delicacy.

"For me, my craft is sailing on, through mists to-day clear seas anon whate'er the final harbor be t'is good to sail upon the sea."

John Kendrick Bangs

A surfacing 40-ton, 40-foot Humpback Whale.

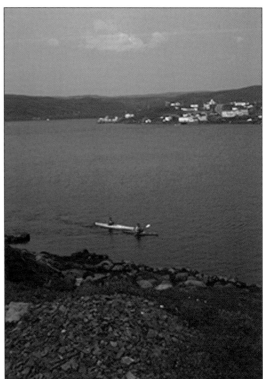

A large pile of basque tile fragments on saddle Island. The Basque whalers brought ceramic tile from Spain for the roofs of their structured buildings.

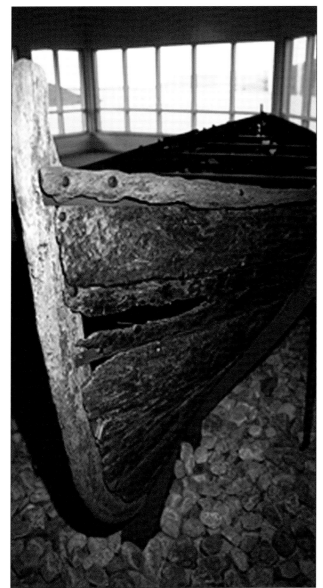

A restored basque whaling chaloupe. The chaloupe, or shallop was approximately 8 metres in length and used to hunt Right and Bowhead whales.

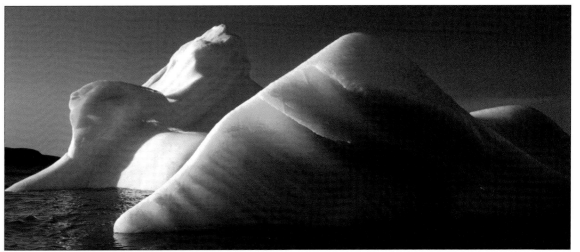

Iceberg west of Red Bay.

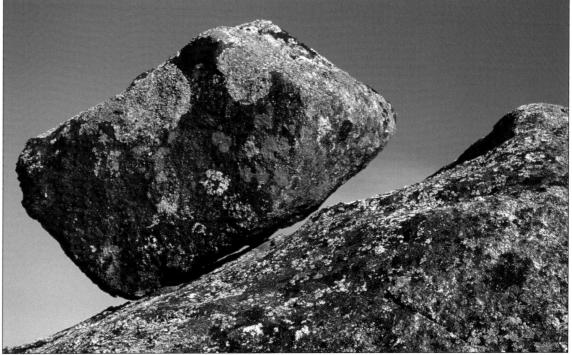

Glacial Eratic – Huge boulder carried by a receding glacier and randomly desposited near Red Bay look-out.

L'Anse Amour National Historic Site/Strait of Belle Isle

The Strait of Belle Isle represents the likely aboriginal access route to insular Newfoundland from mainland Labrador. Human presence along the Strait of Belle Isle dates back 9,000 years.

A National Historic Site, the oldest known burial site in North America is located near the community of L'Anse Amour. Just a few meters from the road leading to L'Anse Amour lighthouse is a mound of rocks that covers the grave of a nine year old Maritime Archaic boy. Here, archeologists unearthed the face down body wrapped with bark or hide, surrounded by offerings of tools and weapons as well as fire pits where food was cooked and eaten.

The Point Amour lighthouse at 109 feet is the tallest

← *At six years old, Thomas lands his first Atlantic Salmon on the Pinware River.*

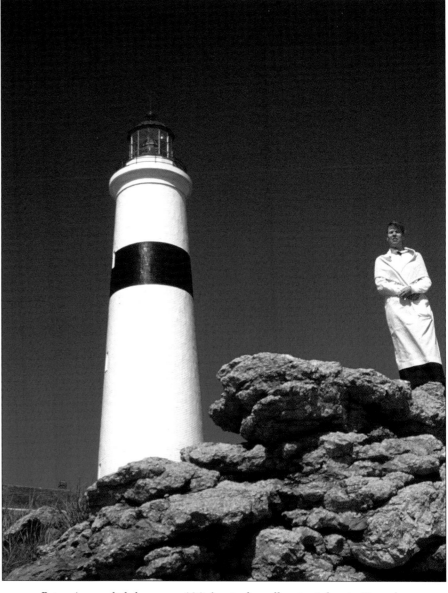

Point Amour lighthouse at 109 feet is the tallest in Atlantic Canada.

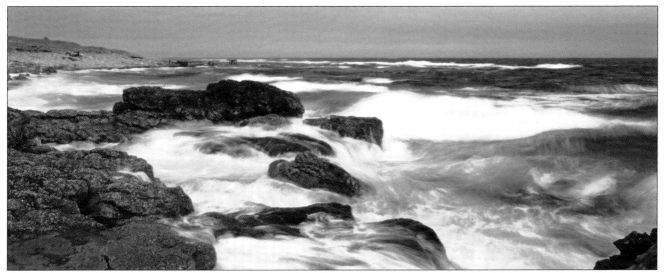

Remains of RALEIGH *wreckage along the shoreline (top left) of Point Amour.*

in Atlantic Canada. Despite the fact it is less than ten nautical miles across the Straits to insular Newfoundland, the Point Amour light projects 18.5 nautical miles up and down the Strait of Belle Isle. Regardless of this impressive beam, it is not sufficient for some. There have been numerous ships wrecked off Point Amour. One of the more spectacular shipwrecks in recent memory was the wreck of the SS *Raleigh*, a British light cruiser loaded with ammunition. En route

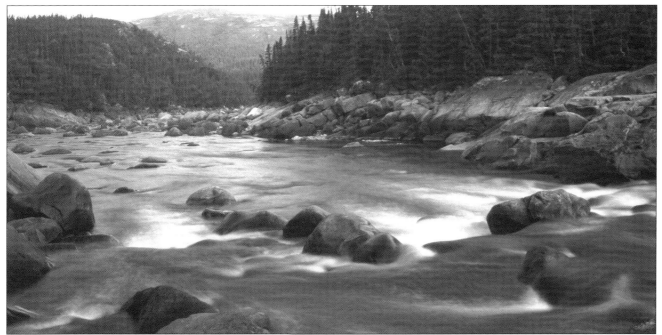

Pinware River, known for its Atlantic Salmon.

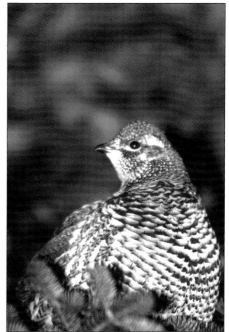

A Ruffed Grouse.

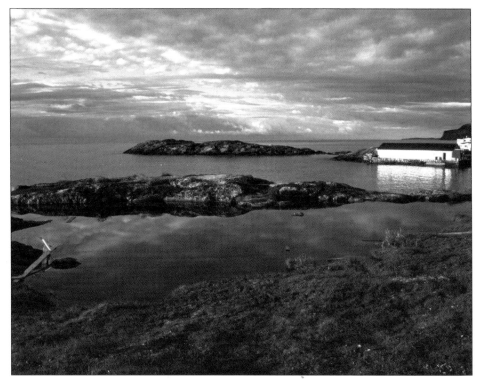

Captstan Island. Wood reminants of frame for tanning Seal skins at left of image. Skins were stretched in the frame and left to soak during the summer months.

to Forteau for a fishing excursion the cruiser met its untimely end August 8, 1922. Remnants of ammunition, locally referred to as "cordite" was gathered by locals and used for fire starters for close to fifty years. Parts of the wreck are still visible on the Point Amour shoals today.

In constructing the lighthouse tower, local limestone had to be quarried from Forteau Point and L'Anse au Loup. At ground level, the diameter of the tower is twenty-four feet with walls a formidable six feet thick. Completed in 1857, the stone tower and attached keeper's dwelling is now a historic structure. Restored to the 1850s period, they share an extensive series of exhibits portraying the maritime history of the Labrador Straits.

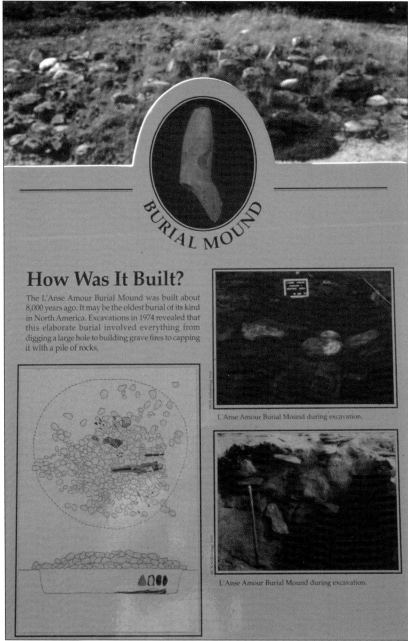

BURIAL MOUND

How Was It Built?

The L'Anse Amour Burial Mound was built about 8,000 years ago. It may be the oldest burial of its kind in North America. Excavations in 1974 revealed that this elaborate burial involved everything from digging a large hole to building grave fires to capping it with a pile of rocks.

L'Anse Amour Burial Mound during excavation.

L'Anse Amour Burial Mound during excavation.

L'Anse Amour Burial Mount in top part of image.

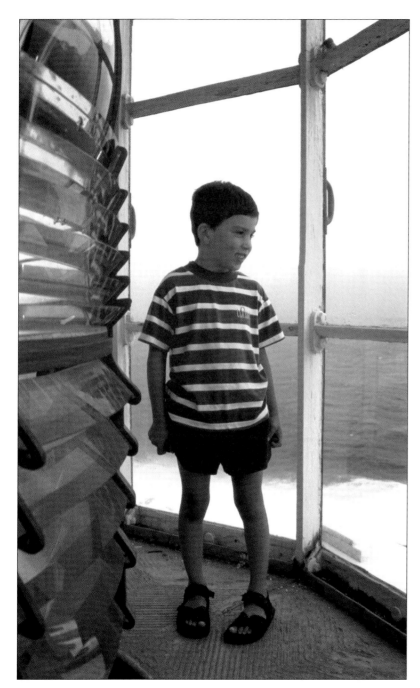

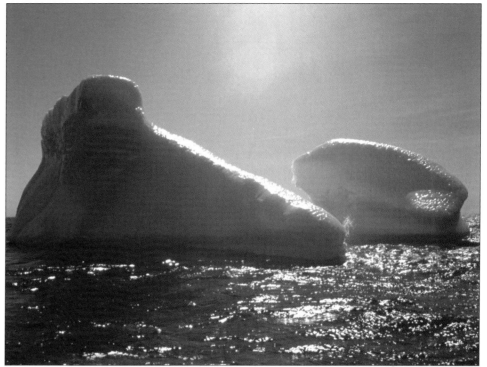

Icebergs are common in the Strait of Belle Isle between May and July (sometimes extending into August) and pose a serious navigational hazard to shipping.

⟵ *In 1822 a French Physicist named Augustin Fresnel invented a lens that is still used today in lighthouses along our seacoasts. Looking like a giant glass beehive, with a light at the center, the lens could be as tall as twelve feet, with concentric rings of glass prisms above and below to bend the light into a narrow beam. The center of the lens (beginning at top left of image) was shaped like a magnifying glass to concentrated the beam making it more powerful. Researchers found that an open flame lost nearly 97% of its light and a flame with reflectors behind lost 83% of its light, the fresnel lens was able to capture all but 17% of its light. With this amazing efficiency, the fresnel lens easily casts its light 30 or more kilometers (20 or more miles) to the horizon.*

L'Anse aux Meadows National Historic Site/ Norstead

Established over 1,000 years ago and discovered less than fifty years ago, L'Anse aux Meadows is the only authenticated Viking site in North America. Now a National Historic Site and a UNESCO World Heritage Site, despite its remote geographical location L'Anse aux Meadows attracts thousands the world over. On my most recent visit to the site, a cruise ship anchored in the Strait of Belle Isle ferried its guests to shore for a site visit. Approximately 1,000 Europeans and Scandinavians experienced first hand the Viking culture in period.

L'Anse aux Meadows was originally named Vinland by Viking explorer Leif Eriksson and used as a base for extended forays into North America. According to the lack of graves and other archeological evidence, it is believed the Viking use of the site was limited to about fifteen years. The discovery of slag, a bog ore smelting and refining by-product, is said to represent the shift from the stone age to the iron age in North America. In excavating the Norse site at L'Anse aux Meadows evidence of other cultures was

Baking a flat bread made of multi-purpose grain, water & dried currants or berries.

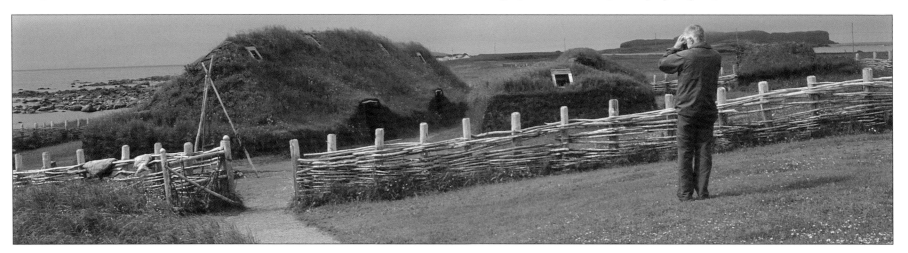

Replica sod houses of L'Anse aux Meadows National Historic Site.

discovered. Although Viking sagas report conflict with local "Skraelings" or aboriginals, archeological evidence to date does not support concurrent use of the site.

Adjacent to L'Anse aux Meadows National Historic Site is "Norstead" a large re-enacted working Viking village. The strengths of each site compliment one another, one being primarily interpretive and the other experiential. A visit to both sites is highly recommended.

Faces of Norstead's cultural re-enactment engaged in traditional Norse life skills of defense, weaving and carding wool.

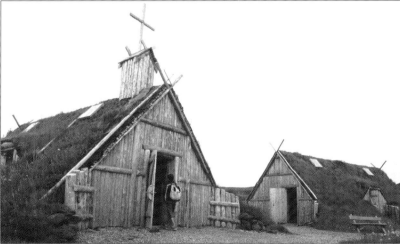

Traditional Norse structures.

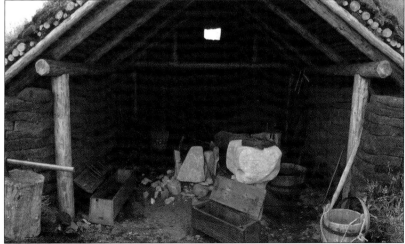

Note the layers of sods in the wall's construction.

"Nature uses as little as possible of anything."

Johannes Keppler

Burnt Cape Ecological Reserve is home to approximately thirty-four rare plant species. In addition another 300 plant species are present, some of which are significant as their presence on Burnt Cape represent the most easterly and/or southerly range of that species. The Cape's relative northern latitude combined with its open, exposed geographical position in the Strait of Belle Isle and elevation creates a micro environment with conditions similar to those found in the arctic. With a mean annual temperature of 1.1 degree Celsius there is little wonder why arctic plant species are an integral part of the reserve.

The relative malleable limestone bedrock making up the reserve is evidenced in "Big Oven" a large sea cave (espoused by some as being North Americas sec-

Burnt Cape Ecological Reserve

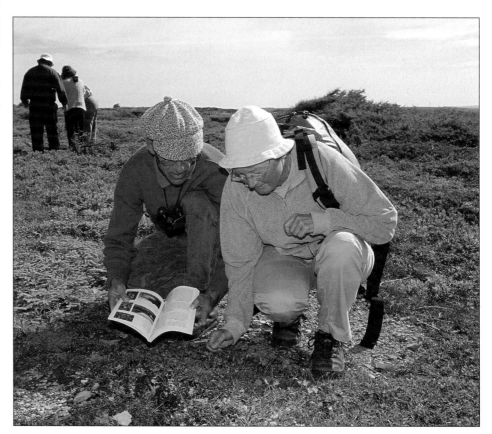

Only the hardiest of plants survive to thrive in this arctic alpine environment.

Verifying a plant species.

ond largest sea cave) located on the western shore of the Reserve.

Active frost sorting features present on Burnt Cape Ecological Reserve are evidenced in stone circles, polygons and stripes. These features indicative of an intense, repeated cycle of freezing and thawing are a rare occurrence and some of the best defined found in insular Newfoundland.

Interruptive tours facilitate visitor interests and highlight site features. Burnt Cape Ecological Reserve is a truly rare find among Newfoundland and Labrador's special places.

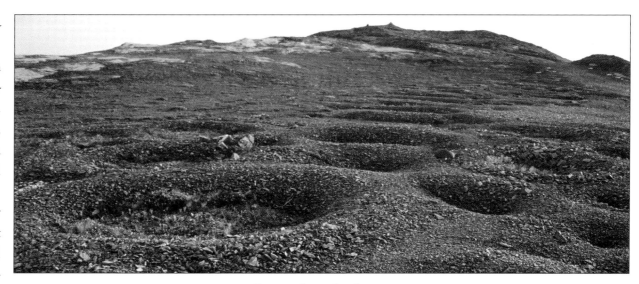

Frost circles and polygons.

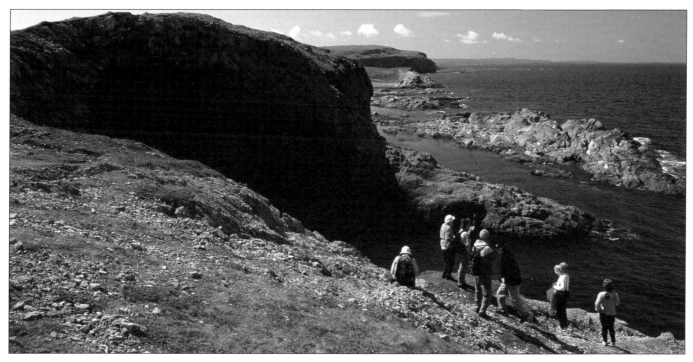

A fantastic view of Big Oven.

Common but pretty harebells.

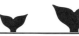

Watt's Point Ecological Reserve

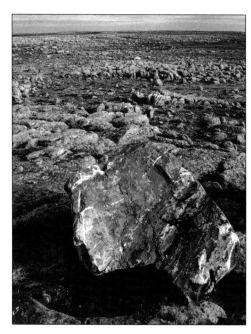

The eastern entry to Watt's Point Ecological Reserve is dramatic. An elevated plateau, partially draped in a flat orange lichen, appears as an anomaly on a coast dominated by a thick rich vegetation landscape. The calcareous (limestone) barrens of Watt's Point Ecological Reserve are internationally significant. According to Parks and Natural Areas the barrens "provide a unique meeting place for plants from two widely separated continents, North America and Western Europe."

The harsh climate of this coast offers rare and uncommon plants free reign without competition from shrubs, trees and other common forms of propagating foliage found throughout the Northern Peninsula. Many of the plant species found in Watt's Point Ecological Reserve are only found in calcareous barren habitat.

The trip to and from Watt's Point Ecological Reserve is part of the experience. Access to the site is via the old coastal highway.

A large tract of calcareous conglomerate rock on the east entry of Watt's Point.

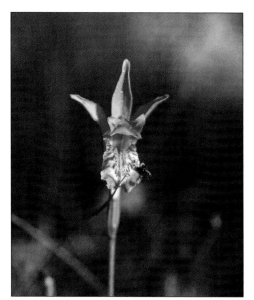

Arethusa or Dragon's Mouth.

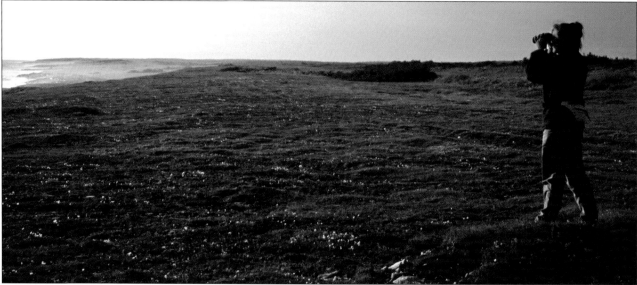

Upland vegitative carpet covering of Watt's Point Ecological Reserve.

A large tussock of moss campion.

Anomalies in the landscape because of their colour.

Inarticulate Brachipod (black circle at top).

29

Hare Bay Islands Ecological Reserve

"The purpose of life is a life of purpose."
Robert Byrne

For a variety of reasons, not the least of which was over hunting, the Eider Duck population suffered near catastrophic declines. By 1988, only eighty-

Common Eider Ducks were once a frequent sight along most of Newfoundland and Labrador's coastline. Traditionally, Hare Bay Islands supported a well endowed Eider population, over 1,000 pairs strong. The tall grasses found on Gilliant, Spring and Brent Islands offered protection for their young from the elements and from predators.

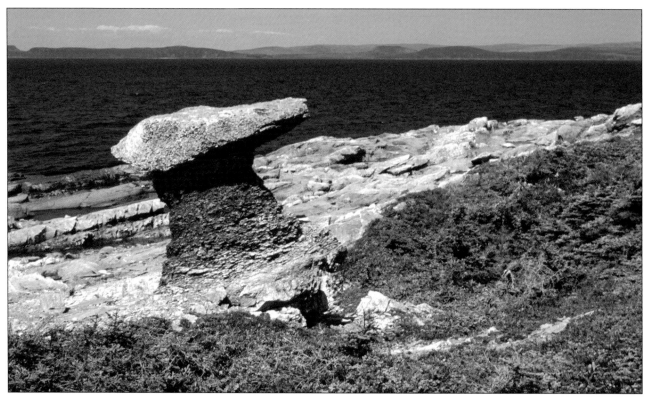
Brent Island signature limestone monolith.

A gaggle of Eider Ducks

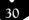 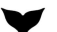

eight nesting pairs remained in the Hare Bay Islands area. Compounding the adult nesting pair's low numbers was an alarmingly low chick survival rate of ten percent. The decline of the Eider Duck population freed up prime nesting acreage for other bird species, some of which are aggressive egg and chick predators. A ban on hunting combined with a program of captive rearing and nesting boxes is successfully re-establishing the common Eider Duck presence in Hare Bay Islands Ecological Reserve.

In addition to the eider ducks, Hare Bay Ecological Islands Reserve is host to a healthy arctic tern population in season and excellent nautiloid fossil specimens.

Obviously related; early ordovician cephalopod fossil (left), snail shell (right).

Chick and unhatched egg.

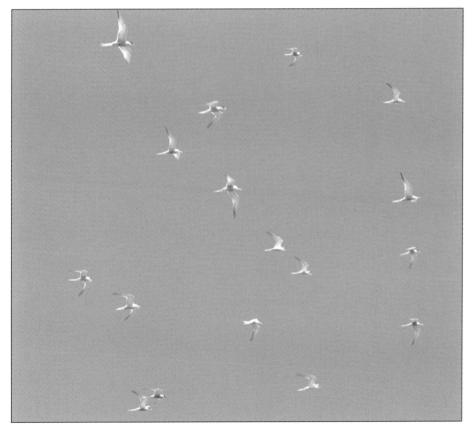

Hare Bay Ecological Reserve is one of the more southerly nesting sites for Terns.

Nesting boxes to protect Eider Duck's eggs and young from marauding gulls.

Port au Choix National Historic Site

"*Then as I gazed across the terraces more intently, ten or twelve similar house pits emerged in the lengthening shadows …. These varied somewhat in size, and most of them were further delineated by richer growths of grass and purple iris in their hollows. Eureka! This was not a small encampment; it had been occupied by numerous hunting families, and later study showed that these prehistoric Eskimoes had camped here while hunting harp seals during the annual whelping period on late winter offshore ice.*"

Harp, <u>Lives and Landscapes</u>, pg 71

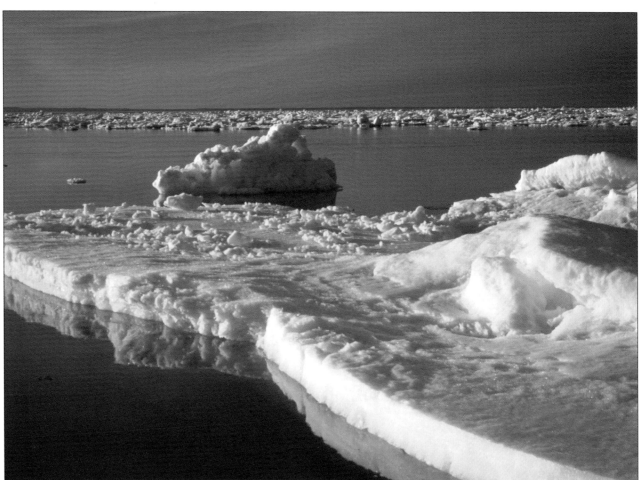

Arctic pack ice. A favourite Seal whelping site.

Blue Flag or Purple Iris… same as those noted by Harp at his moment of discovery.

Elmer Harp was one of a few pioneer archeologists to work on the Great Northern Peninsula and Southern Labrador in the mid twentieth century. His work in this area between 1949 and 1963, documented in *Lives and Landscapes,* is an exceptional book of text and images with a delightful balance between his scientific archeological work and our culture. His discoveries in the Port au Choix area were his most profound. Harp's finds stimulated future finds by others culminating in Port au Choix's designation as a National Historic Site.

Rich natural resources, and a well protected cove attracted a succession of cultures to Port au Choix for varying time frames. The first known inhabitants were the Maritime Archaic, arriving some 4,000 years ago. The Maritime Archaic

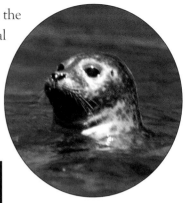

A Harbour Seal.

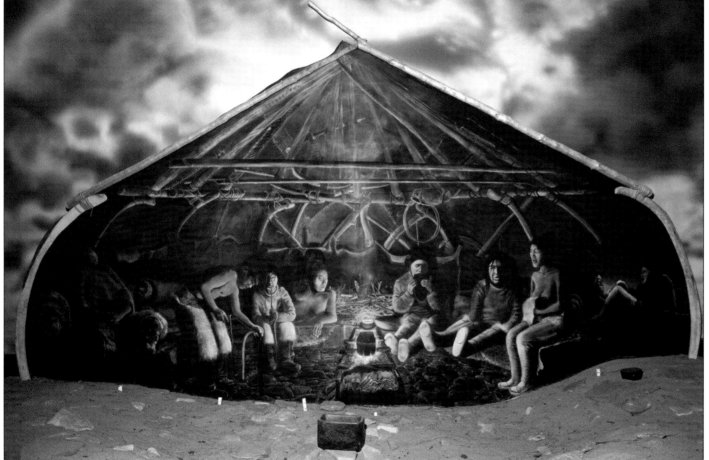

Mural of Dorset winter house by artist William Ritchie, located in Port au Choix National Historic Site Interpretation Centre. Replica construction details based on one of the houses discovered by Elmer Harp in "Phillip's Garden."

burial sites in Port au Choix reveal similiar complexity as the L'Anse Amour site. (See pg. 22) By the time the Dorset Eskimo arrived in 450 BC, the Maritime Archaic had mysteriously disappeared. The subsequent arrival of recent aboriginals, the French and English lead us to the present. The bond between all these groups is that they were drawn to this site by the abundant marine resources.

In Newfoundland and Labrador the Great Auk is synonymous with Funk Island. Much history documents one of North America's first "fast food"

take-outs on Funk Island, located sixty kilometres off Newfoundland's northeast coast. This large Penguin-like flightless bird was hunted for food and feathers. Extinct by the mid 1800s the presence of the Great Auk on Newfoundland's west coast was confirmed when archeological digs in Port au Choix uncovered Great Auk skeletons once hunted by aboriginal groups.

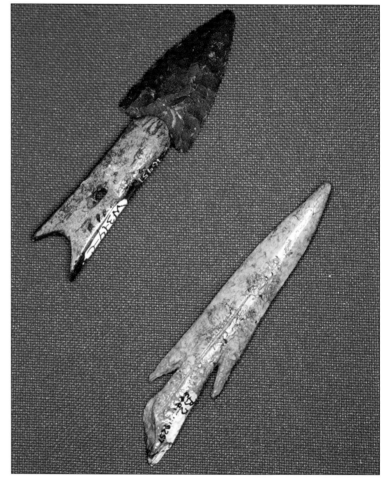

Sunset over the Gulf of St. Lawrence – the same today as it was for pre-historic inhabitants.

End blades.

"The huge island stands, with its sheer, beetling cliffs, out of the ocean, a monstrous mass of rock and gravel, almost without soil, like a strange thing from the bottom of the great deep, lifted up, suddenly, into sunshine and storm, but belonging to the watery darkness out of which it has been reared."

novelist R.T.S. Lowell,
describing Newfoundland in the 1840s

Table Point Ecological Reserve

The initial sightings of Table Point internalize a profound realization of difference. Table Point is a radical deviation from the thickly carpeted, Great Northern Peninsula. Cradled between a vegetative-rich coastal low-

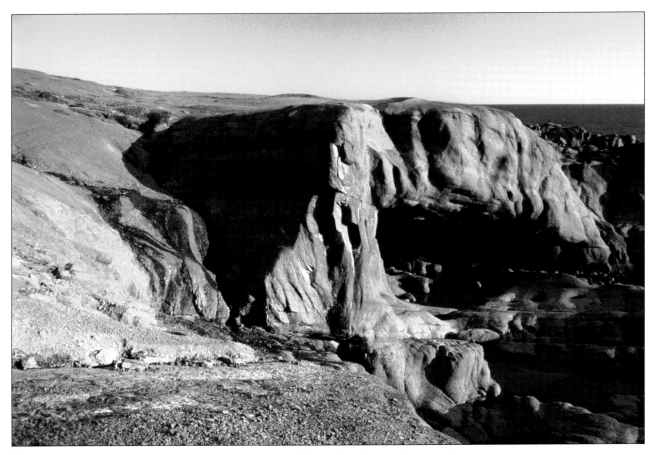

The mouth of a gigantic cavern and the table plateau for which the point is named.

Sheer beetling limestone cliffs of Table Point.

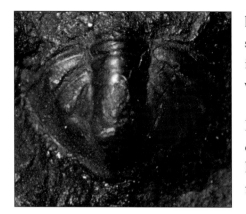

Trilabite from Table Point.
Early/Middle ordovician period.

through the 475 plus million year old shallow-to deep-water limestones of the Table Head Group, which contained abundant, well preserved marine fossils from at least nine different animal groups. Table Point, though geographically compact is full in experiential potential.

Table Point and limestone reinforce the statement:

"In the world there is nothing more submissive and weak than water. Yet for attacking that which is hard and strong nothing can surpass it."

Henry David Thoreau

land plain and the Gulf of St. Lawrence, Table Point's beetling cliffs, rocky, gravel plateau almost without soil, stormy seas under sunny skies and warm sea marine fossils reared from their once watery darkness are in sharp contrast to its bordering ecosystems. Table Point Ecological Reserve is so like Lowell's description of Newfoundland that one wonders if it was a visit to Table Point that precipitated Lowell's observations.

Pockets of exposed limestone are scattered throughout insular Newfoundland's west coast and Northern Peninsula. Limestone is one of the softer rock types found in Newfoundland; it normally erodes at a faster pace than other kinds. Sculpted with the patience of time by the dominant southwesterly wind and waves of the sea, exposed limestone outcrops become windows into the past. In such cases, studying limestone reveals secrets protected by stone for hundreds of millions of years. Table Point is internationally recognized because it exposes a complete section

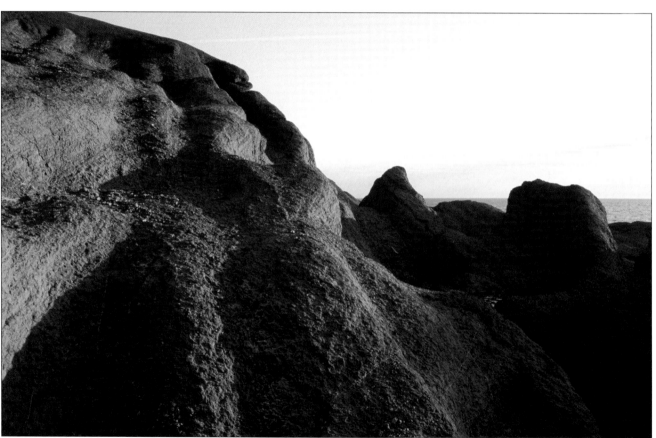

Effects of erosion on Table Point limestone hillside. (Note prominant runoff rivulet tracks.)

"A few hours mountain climbing turns a rascal and a saint into two pretty similar creatures. Fatigue is the shortest way to equality and fraternity and, in the end liberty will surrender to sleep."

Frederich Nietsche

Gros Morne National Park

Gros Morne National Park established in 1973 represents insular Newfoundland's Long Range Mountains and Gulf of St. Lawrence coastal lowlands. It is a landscape of mountains, fjords, raised beach heads, valleys, deep glacial oligotrophic lakes and coastal bogs.

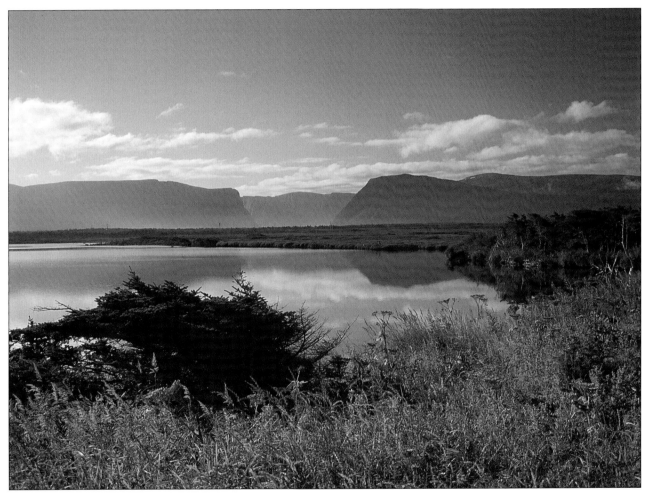

Coastal lowland plain and the Long Range Mountains.

Gros Morne National Park's geological features are diverse and outstanding, having been a major contributing factor to its being recognized as a UNESCO World Heritage Site in 1987. The multi-faceted geological examples manifested in the parks bedrock were strong indicators supporting the "Theory of Plate Tectonics" as it is known today.

The elevation of the Long Range Mountains is a contributory factor in the arctic-alpine barrens populated by woodland caribou, arctic hare and a variety of flora and fauna normally

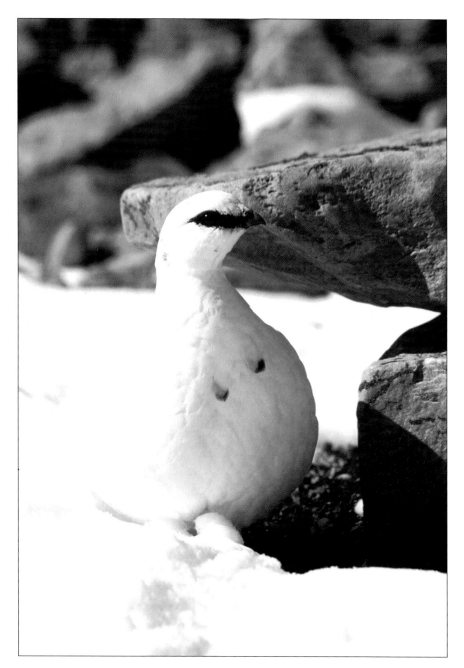

A lone Ptarmigan - near the pinnacle of Gros Morne Mountain.

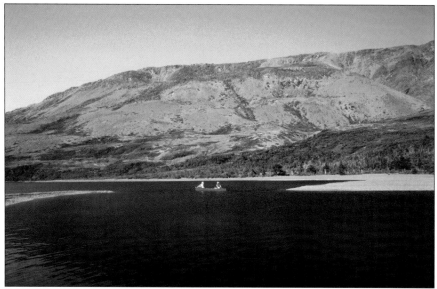

The Narrows of Trout River Pond with Tablelands in background.

Western Brook Pond and the Long Range Mountains first dusting of snow.

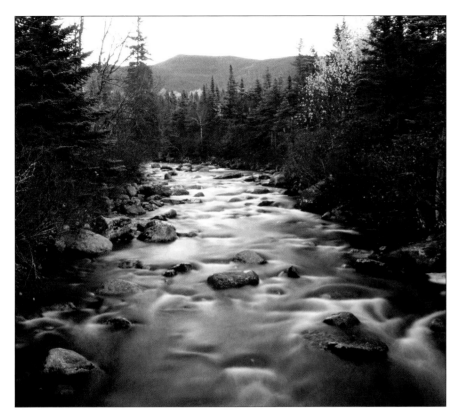

Ferry Gulch Brook near the start of The James Callaghan Trail.

found in arctic latitudes. The Tablelands' serpentine rock with its high metal content inhibits growth, creating a giant bonsai garden for the plants that are able to survive.

Gros Morne National Park is home to a wide variety of natural features, some more renowned than others, but all equally engaging for varying reasons and important as an integral part of the comprehensive package the park has to offer. There is no other designated site in insular Newfoundland that offers the breath and depth of experience available in Gros Morne National Park.

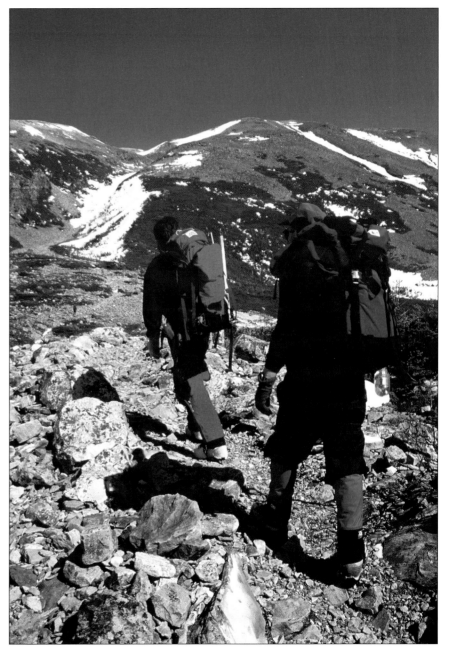

Ascending the base of Gros Morne Mountain.

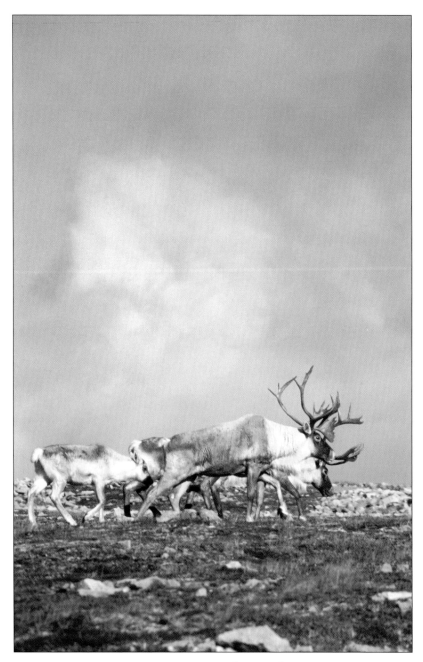

Long Range Caribou Herd.

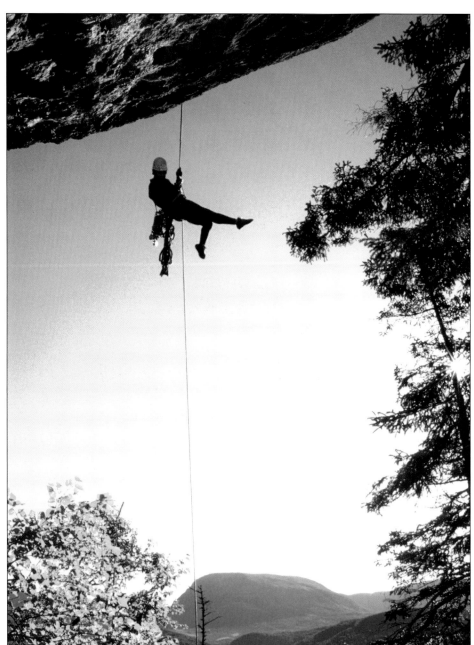

Hanging out in Gros Morne National Park. Gros Morne Mountain in background.

 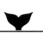

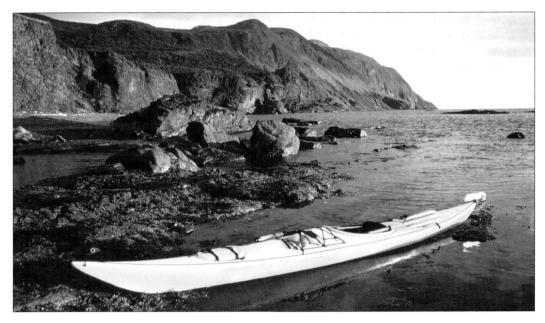

Shoreline along the Green Garden Trail.

Shallow Bay with its sand dunes and dune grass.

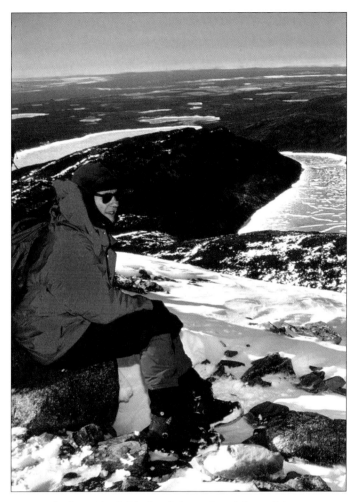

Overlooking Ten Mile Pond from Gros Morne Mountain.

"The earth does not argue,
Is not pathetic, has no arrangements,
Does not scream, haste, persuade, threaten, promise,
Makes no discriminations, has no conceivable failures,
Closes nothing, refuses nothing, shuts none out."

Walt Whitman

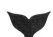

Bay of Islands/ Corner Brook

> *"Though with those streams he no resemblance hold, whose foam is amber and their gravel gold;*
> *His genuine and less guilty wealth t'explore, search not his bottom, but survey his shore."*
>
> Sir John Denham

Corner Brook has a long association with explorers and adventurers. One of the more famous is the British explorer and cartographer Captain James Cook. In 1767, Cook surveyed and mapped the Bay of Islands. Part of a five year official coastal survey of insular Newfoundland that included land maps, depth soundings, charting coastal water depths and navigational hazards, Cook's accuracy led to his maps being used for over 200 years.

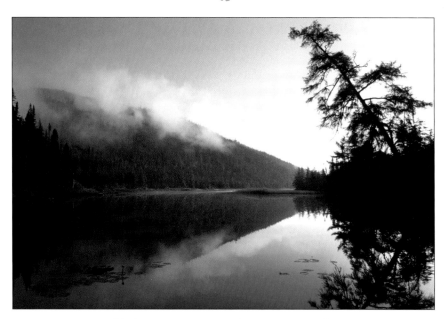

Early morning mist on Goose Arm Brook.

Taking a break on arctic pack ice en-route to Woods Island, Bay of Islands.

Enjoying the Insectarium.

Riding the Blow Me Down Mountain peaks.

Ironically Cook's own ambitions led to his ultimate demise. By his own admission "...I had ambition not only to go further than any one had been before, but as far as it was possible for man to go..." His later travels led him throughout Australia, New Zealand and other South Pacific islands. On Valentines day in 1778 while overwintering (certainly a matter of perspective) in Hawaii (then Sandwich Islands) Cook met his end in an unfortunate encounter with island natives. The Captain James Cook Monument in the city of Corner Brook is a National Historic Site exhibiting copies of the charts mapped by Captain Cook. This site is easily accessible and offers a panoramic view of the Bay of Islands.

Today the City of Corner Brook, embraced by the soaring and faulted Long Range Mountains is home to many a modern explorer and adventurer. Located in the midst of a wide variety of natural phenomena with access to organized pro-

A well developed trail system throughout the core of Corner Brook links many of the city's amenities.

Ice climbing a coastal frozen waterfall.

grams and/or wilderness, Corner Brook and area is Newfoundland's unofficial outdoor adventure activity playground. Within five minutes of downtown Corner Brook are the nationally recognized Marble Mountain downhill ski resort, Blow-Me-Down Cross Country Ski Park, tubing, snowmobiling, fishing, mountain biking, caving, sea kayaking, hiking and even buried treasure. Diverse and large enough, Corner Brook has a reputation for gratifying those seeking a family friendly fun adventure or the hard core high end adrenalin aspiring adventurer explorer.

For those seeking a little more intrigue Corner Brook and area is not lacking. According to local legend, on Shellbird Island, located in the mouth of the Humber River is the site where Spanish pirates buried a treasure that remains undiscovered. Overlooking the island and its treasure is the "man in the mountain," a naturally sculpted face of an old man with the taciturn look of a watchman guarding his treasure.

Thrilled with the hill.

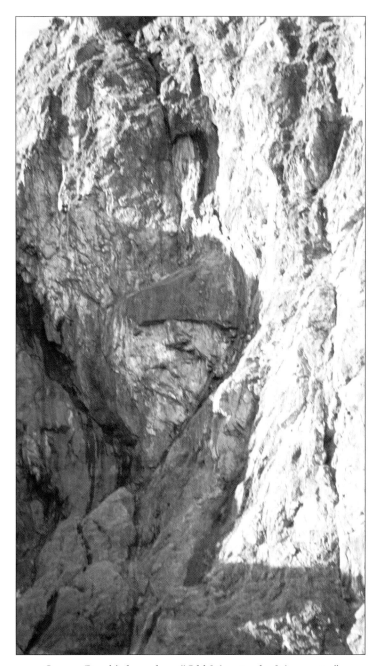
Corner Brook's legendary "Old Man in the Mountain."

Marble Mountain, Humber River in the background.

Humber River/ Sir Richard Squires Memorial Provincial Park

"In the woods we return to reason and faith."

Emerson

If "Big Falls" of Sir Richard Squires Memorial Provincial Park was more easily accessible, it could be Newfoundland's "Yellowstone!" Within the park is a stretch of the Humber River that includes "Big Falls," a three meter vertical wall of water that traverses the rivers width. The Humber River is world renowned for its run of Atlantic Salmon and Big Falls is renowned for leaping Salmon!

Atlantic Salmon pooling together.

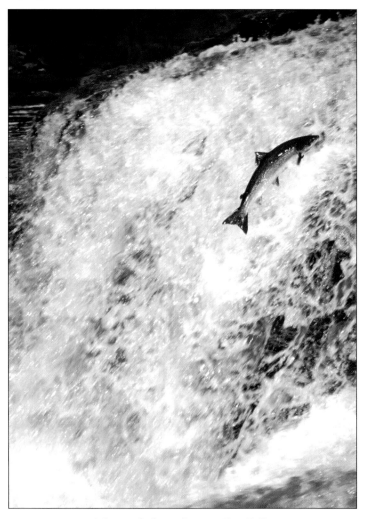

Atlantic Salmon leaping Big Falls.

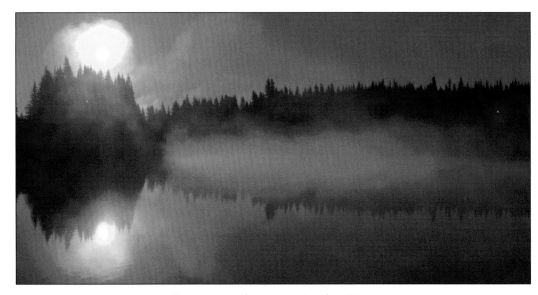

Sunrise over the Upper Humber River.

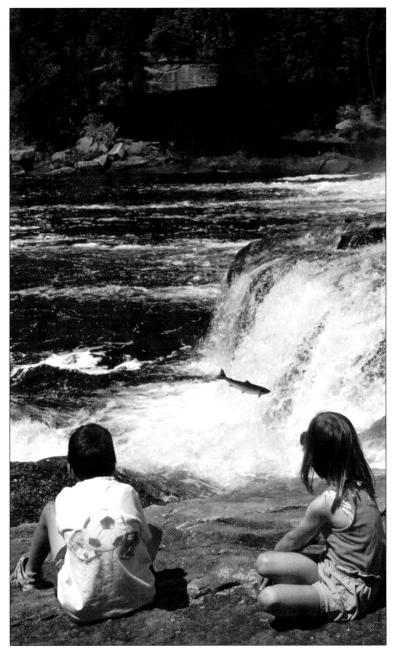

Children enjoying salmon jumping the falls.

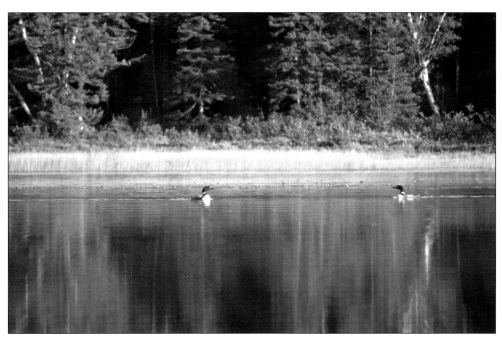

Frolicking loons on the Upper Humber.

Atlantic Salmon are anadromous fish. As adults they live in the sea but return to the fresh water of their native river's headwaters to spawn. The annual Salmon migration in Newfoundland rivers usually runs from May to October. After successfully navigating the gauntlet of fisher folk and arriving at Big Falls the Atlantic Salmon flash their prowess and persistence to leap obstacles in their upstream journey to their birthplace and spawning ground. The viewing ledge borders the river's edge. It is that close that on occasion a flustered fish lands at your feet.

One interesting side note is the road used to access Sir Richard Squires Memorial Provincial Park is the old Trans Canada Highway.

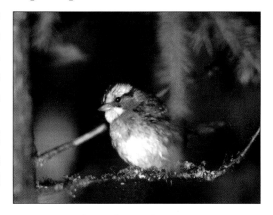

White Throated Sparrow.

Main River: Canadian Heritage River.

In *Voyages: Canadian Heritage Rivers*, author Lynn Noel states: "The river moves from land to water to land, in and out of organisms, reminding us what native people have forgotten: that you cannot separate the land from the water, or the people from the land." After experiencing the Main River, it remains with you forever!

In Lynn's first descent of the Main, after successfully navigating a healthy class 3 rapid that had her adrenalin flowing about the speed of the rushing water; Lynn cooly turned to me and commented: "that of all the heritage rivers she had run, and she had been on most, it was the most challenging white water she had ever paddled!" The Main River offers exceptional paddling opportunities, salmon runs and wildlife viewing.

Originating atop the legendary Long Range Mountains along the eastern borders of Gros Morne National Park the Main River flows south-

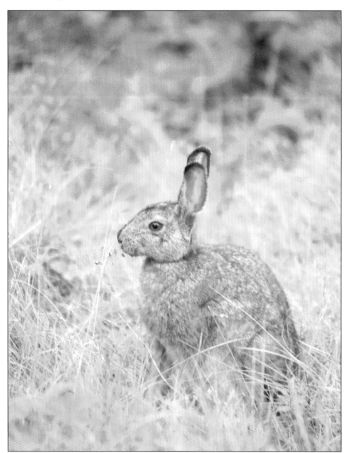

Snowshow Hare.

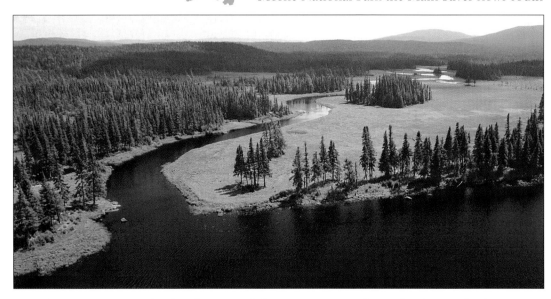

A tributary emties into Big Steady – its park line appearance is the result of spring floods pruning lower limbs and clearing away debris.

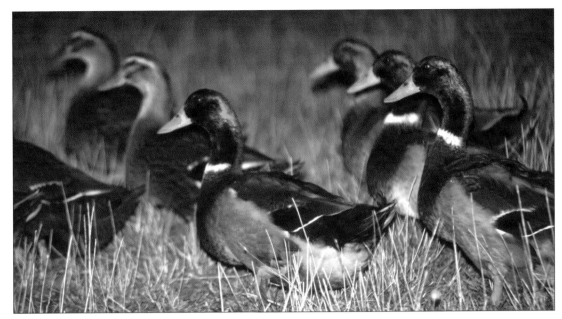

When paddling the Main it's important to have your "Ducks in a Row."

Thick "Old Man's Beard." Typical of a mature boreal forest.

east through tundra-like barrens, majestic softwood forests and unique grassland flood plains, and on to the Atlantic Ocean where it empties into Sop's Arm, White Bay. The abundance of wildlife found in the Main River watershed is similar to that of Gros Morne.

The quiet waters of Big Steady is one of three unique grassland flood plains in Newfoundland. Its park like appearance occurs naturally as each spring flooding waters and ice clear away all surface debris and prune branches from the tree trunk's lower six feet. The boreal forest ecosystem is an international anomaly as the Balsam fir grow up to three times their normal age, up to 260 years old! The growth dynamics of this boreal forest ecosystem is similar to that found in tropical rainforest.

On January 8, 1991, the Main River on the Island of Newfoundland's first river nominated to the Canadian Heritage River system in 1991 and designated in the fall of 2001. The Main River is a river full of powerful opportunities and experiences.

The Main River watershed is threatened by logging. The geographical lie of the land dictates that if the virgin timber is cut, erosion will occur. Scientists recognize that after clear-cutting, the original forest type will never regenerate and if we are to preserve what we value then perhaps we should consider the words of Mahatma Ghandi, "You must be the change you wish to see in the world!"

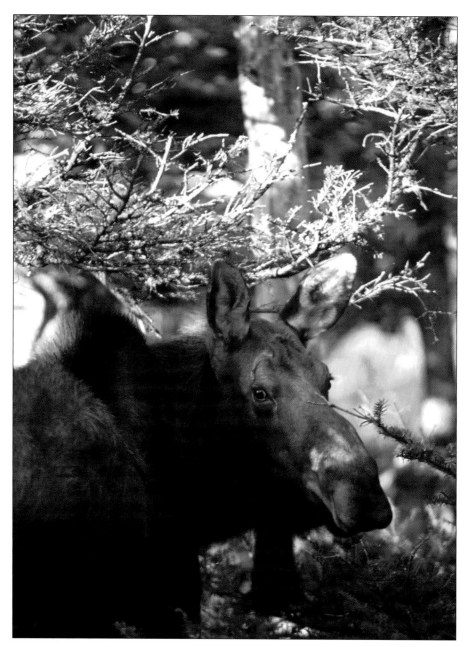

Moose sightings are common in the head waters of the Main River.

Descending the canyon. Nearly 20 kms of continuous and thrilling white water.

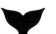

ON SHANAWDITHIT, THE LAST KNOWN BEOTHUK

"A gentleman put a looking glass before her and her grimaces were most extraordinary, but when a black pencil was put into her hand and a piece of white paper laid upon the table, she was in raptures. She made a few marks on the paper apparently to try the pencil; then in one flourish she drew a deer perfectly, and what is most surprising, she began at the tip of the tail."

Rev. William Wilson

Notre Dame Bay is one of North America's best kept modern day secrets. It exhorts the modern mariner to explore. With over 350 islands, thousands of kilometres of coastline, an abundance of natural history, a rich pre- European and European history, Notre Dame Bay will always likely beckon more.

Although the Beothuk presence is documented in many areas of insular Newfoundland, the tribes strongest ties were to the Exploits River, Notre Dame Bay area. Attracted by the abundance of Cod, Salmon and inland fur, the Beothuk overwintered inland and spent the summers along the coast. Unfortunately for the Beothuk, European demands for furs and fish resulted in early European settlers competing for the same natural resources sustaining the Beothuk. The resulting conflict ultimately led to the untimely extinction of the Beothuk.

Notre Dame Bay/Tilting National Historic Site

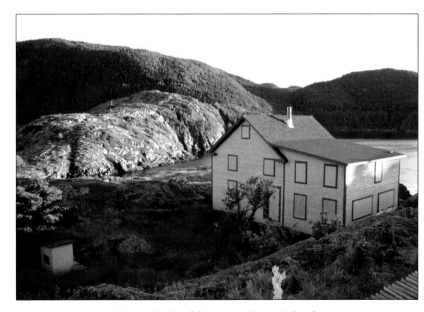

Restored school house on Burnt Island.

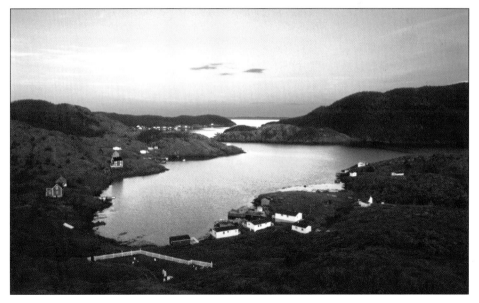

The tickle between Burnt Island (left) and Exploits Island (right).

Exploits and Burnt Islands reflect much of the Beothuk European struggle. The graveyard on Burnt Island contains the graves of John Peyton junior and John Peyton senior. Peyton Sr. was wary and unfriendly toward the Beothuk whereas Peyton Jr. befriended them, taking one of the last surviving members Shanawdithit into his home.

Just across the tickle from Burnt Island, living on Exploits Island is Richard and Lydia Wells who refused the governments offer to resettle in the 1960s only to remain as the communities sole permanent residents and maintain a traditional lifestyle. With no fear, not even from a vagrant Polar Bear in spring, Richard (in his early seventies) stated: "No! I wasn't afraid, I'd take him down with my *bear* hands!"

The numerous quality anchorages and island protection from the exposed Atlantic Ocean is drawing more boaters back to the resettled quarters in the bay as the once thriving, then dying communities are now revitalized each summer in the form of a coastal cottage country.

Other historical sites include Boyd's Cove Interpretation which offers an in depth look at Beothuk culture and Tilting National Historic Site located in the community of Tilting on Fogo Island.

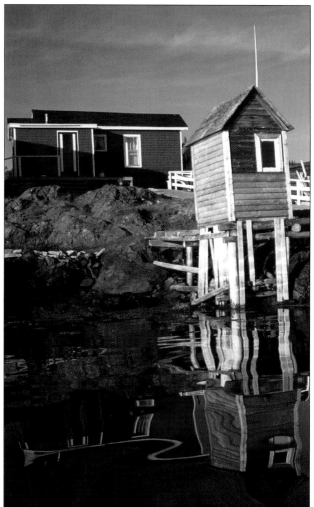

Traditional seaside outhouse – flushed twice a day with the tides.

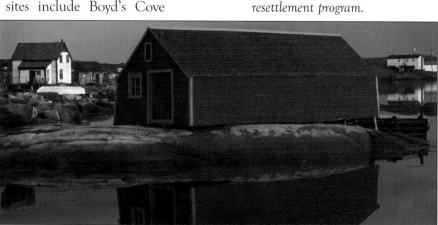

Richard and Lydia Wells. The only perminant residents of Exploits Island since the 1960's resettlement program.

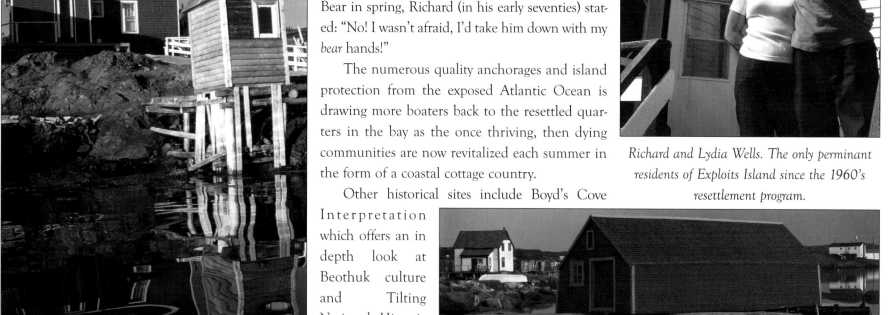

Traditional "store" (shed) in Tilting Harbour, a recently designated National Historic Site.

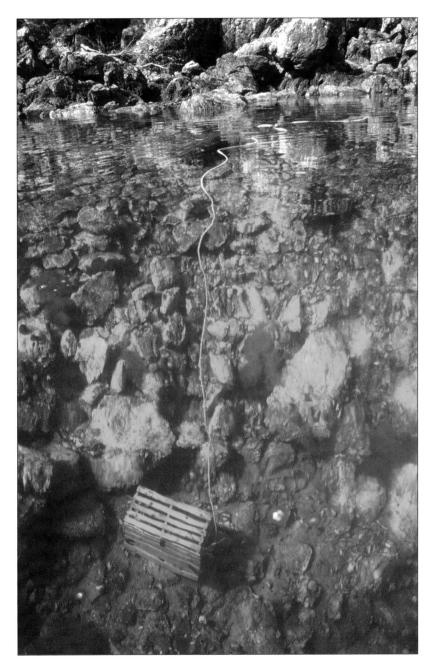

Water clarity in most areas is spectacular.

Gravesite of John Peyton Jr. and John Peyton Sr. (Burnt Island).

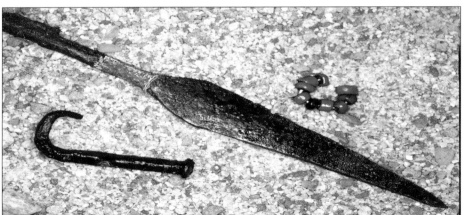

Beothuk beads and European trading pieces.

Bay du Nord/ Wilderness Area/ Middle Ridge Wildlife Reserve

"The clearest way to the universe is through a forest wilderness."

John Muir (1858 - 1932)

The Bay du Nord Wilderness Area and Middle Ridge Wildlife Reserve are home to insular Newfoundland's largest caribou herd, some 15,000 strong. The primary wintering ground is in the Bay du Nord while calving occurs in both areas. Essentially untouched since the beginning of time any visit transcends time and successive cultures that have frequented this special place. Primarily composed of extensive barrens, kalmia heaths, bogs and fens, this upland plateau is broken only by two rocky outcrops. To the southeast is the Tolt that from a distance appears like a small volcanic mound. Located in the northwest quadrant of the Wilderness Area is Mount Sylvester, highlighted by fluted rock and named after an Indian guide, Sylvester Joe, who served as William Cormack's guide in the first documented east-west traverse of insular Newfoundland.

Another area designation is the Bay du Nord River which has been nominated to the Canadian Heritage River System. Much of the Bay du Nord River system traverses the Bay du Nord Wilderness Area before emptying into the sea near the resettled community of Bay du Nord. This river system is for expert river paddlers only, whereas the river's headwaters offer similar wilderness adventure with fewer demands.

For all of these areas, fishing is exceptional and potential wildlife sightings include Moose, Caribou, Black Bear, Willow Ptarmigan, Canada Goose, American Black Duck, Green-Winged Teal, Common Goldeneye and Common Merganser in their respective habitat.

My first trip to the Middle Ridge Wildlife Reserve displayed some the wildness and periodic deliverance of this place. Approaching a couple of barren grazing Caribou with calves from a distance of a couple of hundred meters, a rarely viewed sequence of events occurred. A snorting Caribou in the process of giving birth exited the forest, bordering the open barrens with the grazing Caribou. Like on cue, another ten to fifteen Caribou with young calves emerged from cover and en masse headed away from the area. About one

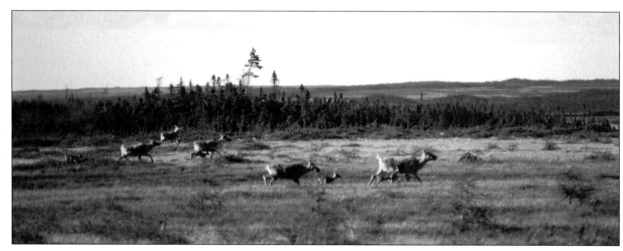

Caribou and calves running from a black bear and two cubs.

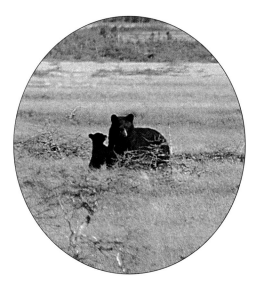

minute later a Black Bear with two young cubs emerged from the same thicket as the snorting Caribou. The bear followed the Caribou fifty metres, looked back waiting for the two cubs and then appearing to give up on the Caribou, changed direction moving towards us. About thirty meters away from us, the mother Bear took scent of us, turned and bolted with the two cubs in hot pursuit. Bears are known to kill approximately one third of new born Caribou calves. This appeared to be a day for the Caribou.

There are few pockets of relatively unexplored wilderness left in the world; the Bay du Nord Wilderness Area is one!

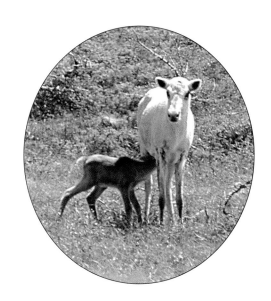

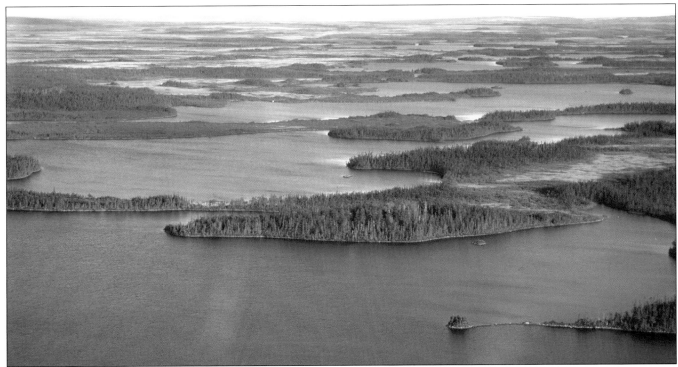

The headwaters of the Bay du Nord are surrounded by forest thickets and string bogs.

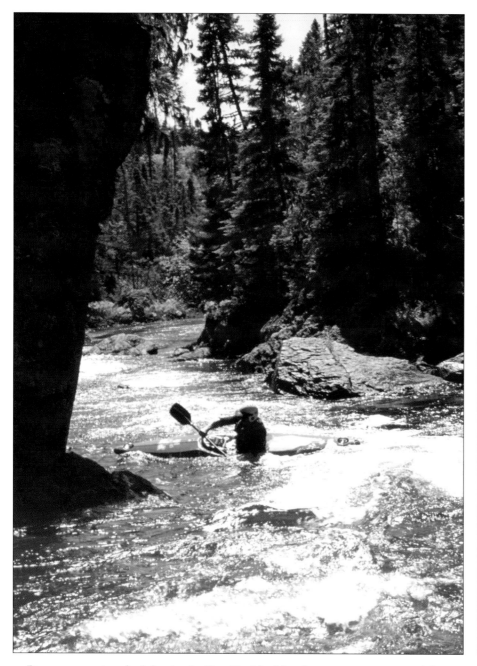

Rivers connecting the lakes in the Bay Du Nord headwaters are narrow and fast.

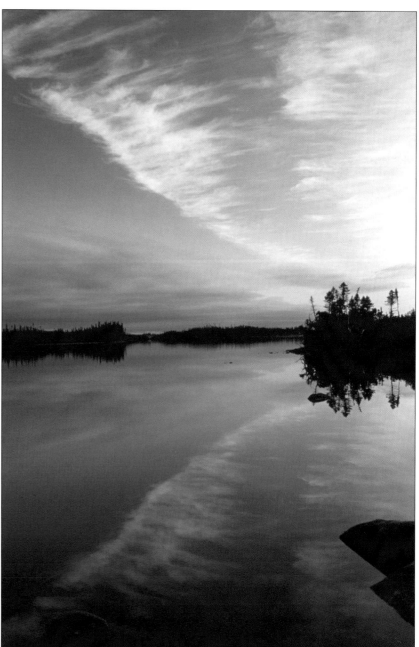

Middle Ridge in early morning.

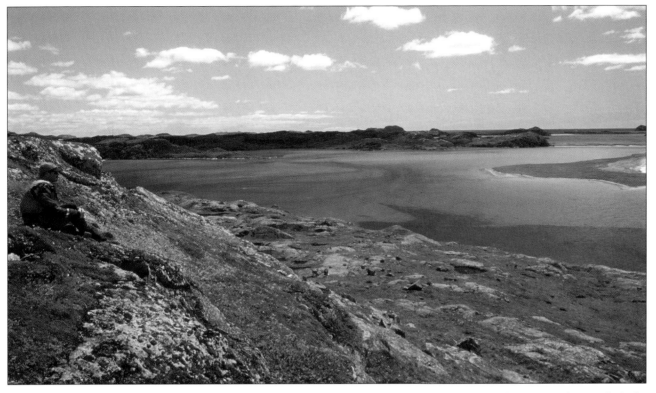

The confluence of Aarons Arm, Grandy's River and Ocean Currents. Currents are evidenced by water colour with fresh water being the darkest in colour.

Sandbanks Provincial Park/Burgeo

Not long liberated from isolation, (road paved in 1992) Burgeo and area exhibit many of the charming characteristics typical of communities on Newfoundland's south coast. Traditional fishing stages and stores are the norm in this community where many residents are more familiar traveling on the water than on land.

An expansive coastline among the bays, inlets, coves, tickles, arms and islands offer access to resettled communities, aboriginal haunts and wildlife staging areas. This area features some of insular Newfoundland's best sandy beaches and undulating sand dunes. Sandbanks Provincial Park is set aside to protect a representative portion of this pristine and fragile environment.

These beaches and dunes are dynamic phenomena. Freshwater currents and saltwater tides are constantly eating away and/or depositing sand, changing the lie of the land even in the past 200 years. A comparison of the 1800s map with the present reveals the changes that have occurred such as an island evolving from a peninsula.

The water color and clarity among the beaches of Burgeo is among the best in the province. In fact, most compare it with more southern environs. Some of Newfoundland's best examples of fresh, brackish and salt water coloration are visible in the Aaron's Arm - Big Barasway region. Big Barasway is also a staging area for waterfowl, seals and caribou. The Bay du Loup face in the rock is just one of Burgeo's many jewels worth exploring.

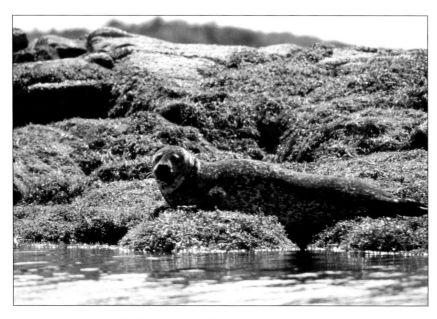

An adult Harbour Seal basking in the sun in the barasway.

Traditional stages and stores in Burgeo.

Sand dune beach separating Barasway and open ocean.

Sunset from Burgeo Look-out.

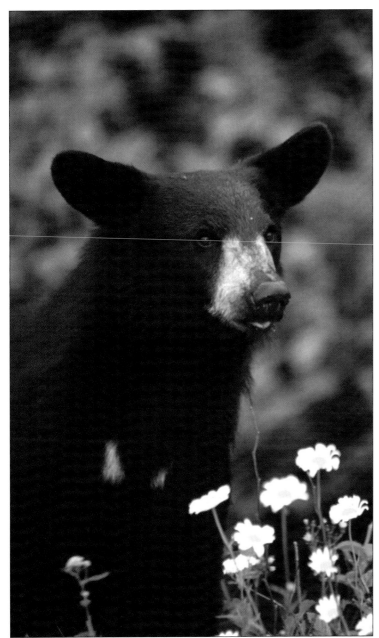

A Juvenile Black Bear.

> *"There is a pleasure in the pathless woods,*
> *There is a rapture on the lonely shore,*
> *There is society, where none intrudes.*
> *By the deep sea, and music in its roars;*
> *I love not man the less, but nature more."*

George Gordon/Lord Byron

Terra Nova National Park

Terra Nova National Park was the first national park established in Newfoundland and Labrador. Featuring a healthy combination of well developed community campground facilities and back country wilderness access and camping, Terra Nova National Park is a popular destination.

Initially designated to protect the Atlantic uplands and boreal forest of eastern Newfoundland, in recent years Terra Nova has assumed strong marine and coastal initiatives. Park themes such as "Fingers of the Sea" in conjunction with the development of over eighty kilometres of hiking trails, much of which is part of the Parks Coastal Trail network, offer intimate access to the world's richest ecosystem, the interface of the marine and terrestrial ... the coastline! Like rivers and tides, all life forms eventually gravitate towards the coast.

Terra Nova features an abundance of wildlife, flora and fauna, from Whales, Giant Jellyfish, Salmon, Moose, Bear, Lynx, Bald

Enroute from Minchen's Cove.

Water clarity of the Narrows make for lots to see on a clear day.

Coastal hike near Malady Head.

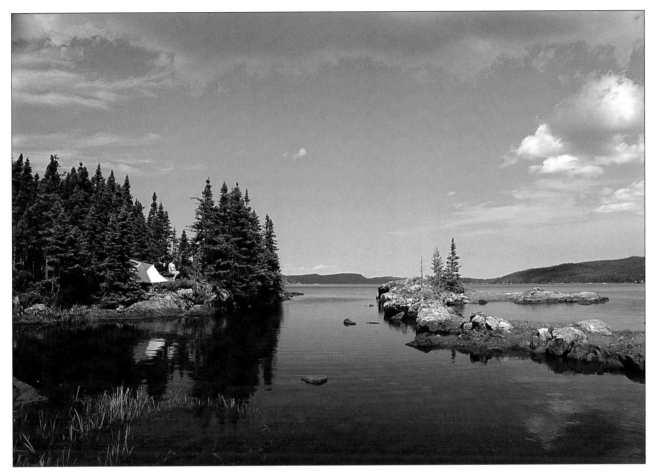

Coastal campsite at South Broad Cove.

A raspberry ready for picking

Canadian Burnet/Bottle Brush.

Eagles, Osprey, orchids, sundew and pitcher plants to name a few. These life forms know no boundaries other than their own providence to survive.

On waking up to a rustling outside our tent one fall morning in Minchens Cove we discovered a Moose browsing non-chalantly fifteen feet from our tent. Minchens Cove is further example enrichment experience opportunities in the park. Settled by European descendents from the 1860's to mid-1900's Minchen's Cove was one of many marginal coastal communities that is now slowly achieving near mythical status. Listening to the story of a hunting party from Minchen's Cove encountered their first moose and the description of this a strange beast: "a cross between a horse and a caribou?" A swim in Minchens Cove Pond and a walk by the com-

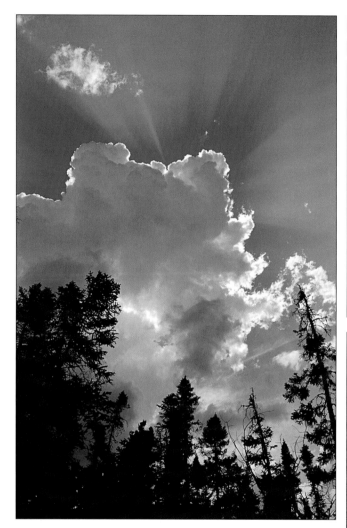

Sun eclipsed by a cloud.

munity graveyard offers a sense of the freedom, frolic and hardship these early settlers endured. Today, these resettled communities offer beautiful secluded back country camping locations along trails that are easily accessed by foot, canoe, sea kayak, or shuttle boat.

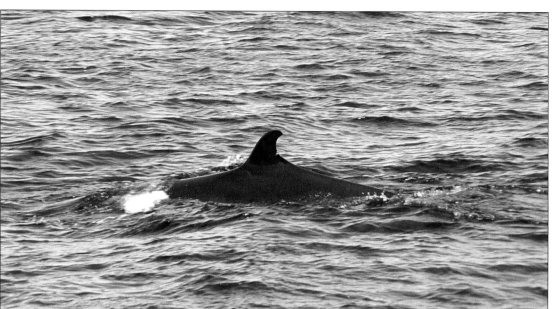

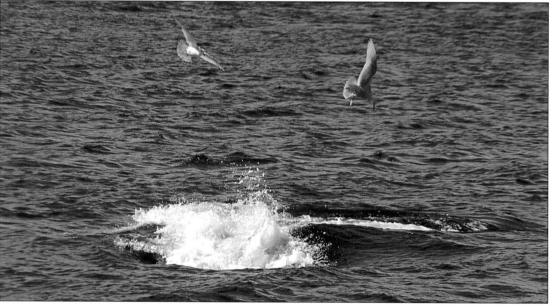

A Minke Whale lunge feeding at the surface. Gulls usually follow the feeding whale scavenging leftovers.

"One touch of nature makes the whole world kin."

Shakespeare

The Burnside and Alexander Bay area of Bonavista Bay offers access to a variety of documented aboriginal sites. Inhabited relatively successively (but not exclusively) by Maritime Archaic, Paleo-Eskimo and Beothuck peoples for at least 5,000 years, Bloody Reach, Bloody Point Rock Quarry and The Beaches high-

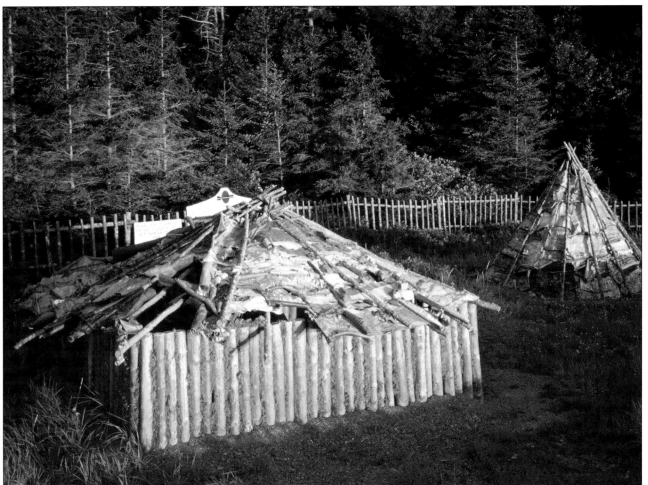

Replica Birch Bark Mamateek and Teepee at "The Beaches."

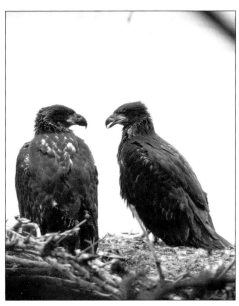

Eaglets just days before their first flight.

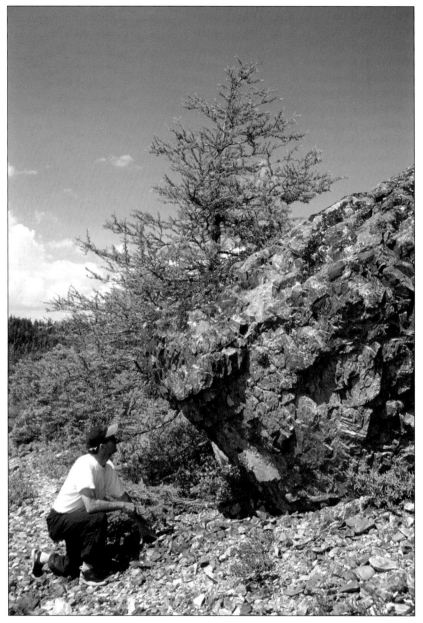

Bloody Point rock quarry: used by successive aboriginal cultures for some 4,000 years.

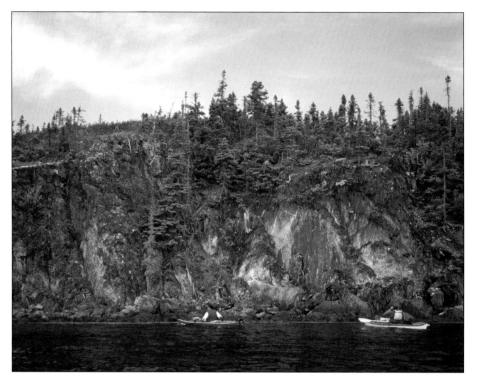

Rock faces rich in iron oxide provide a low grade ochre substitute used by the Beothuks and likely a contributing factor in them being referred to as Red Indians.

light the natural resources and contributing geographical conditions that attracted these subsistence groups over such an extended period.

Archaeological evidence reveals that many of the sites were located in Bloody Reach, a relatively large but protected waterway bordered by coves, peninsulas and islands offering easy access to marine and terrestrial quarry.

Bloody Point Rock Quarry is recognized as the largest Aboriginal quarry found to date anywhere in Newfoundland or Labrador. There are literally tons of rejected or scrap rock flakes, so plentiful that the pile appears as a scree slope. Bloody Point Rock Quarry has revealed important evidence of the stone-age technology used in Newfoundland prior to European settlement.

The Beaches, located at the northwest tip of Bloody Reach once contained nineteen Beothuck "house pits". Many of these "house pits" are visible today as

well as a life-size mamateek and teepee. The notion of sustaining nineteen households with stone-age technology is noteworthy. Staying on site long enough to see the effects of high and low tides reveals the secret. At low tide it is possible to easily walk across the tickle keeping your feet almost dry and attach a net on both sides. As the tide rises, water flows over the bar up to a level of three to four feet. As the tide receded the aboriginals could easily retrieve their catch. Considering the minimal risk and ease of hunting/fishing at The Beaches compared to paddling forty kilometers in open canoe on the exposed Atlantic Ocean to the Funks (which the Beothuk were known to do) The Beaches must have been like heaven on earth.

Although these three sites require boat transport, they are well worth the effort. A trip to the museum in Burnside offers a more detailed introspection and synthesis of events from a professional's perspective.

Visiting and paying respects at a documented Beothuk gravesite. The overhanging rock is a typical feature of coastal burial sites. It is believed it would help protect the deceased. The dead were normally buried with birch bark and red ochre, both of which were superficially present at the site. →

(Note: It is illegal to dig up, move, destroy, damage, alter, add to, mark or interfere with an archelogical artifact in Newfoundland and Labrador. If you discover an artifact, it should be left on site and photographed, location accurately documented and reported to the Provincial Archeology Office.)

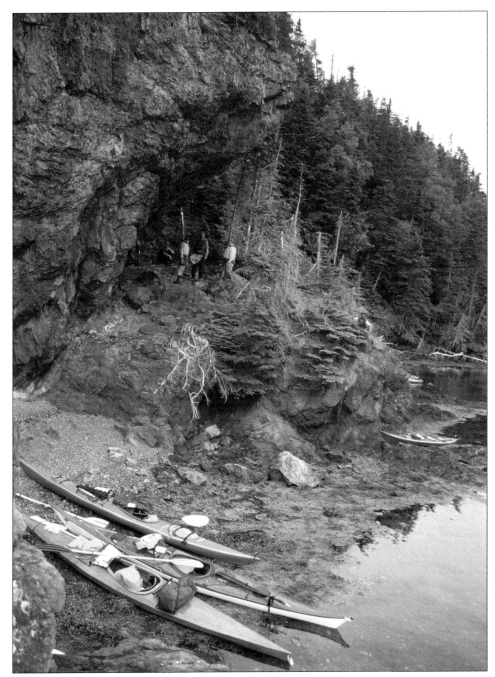

Ryan Premises National Historic Site

"How sweet the moonlight sleeps upon this bank."

Shakespeare

Located in Bonavista, The Ryan Premises National Historic Site is a restored merchant's premises which commemorates the East Coast Fishery.

The restored waterfront properties acquired by James Ryan in 1869 served the headquarters for James Ryan Ltd. and include the Proprietor's House, Retail Shop, Fish Store, Salt Shed and Carriage Shed. Similar

to Battle Harbour National Historic District, a synthesis of period trades, tools, architecture, economic system, social structures and lifestyle are accessible to the visitor through artifacts, interactive exhibits, photographs, a theatre and just "being there." Worn floor boards, color schemes, leaching salt all tell a story and add an ambiance of the past.

James Ryan Ltd. was more than a local business. For over 100 years the Ryan family prospered buying and curing

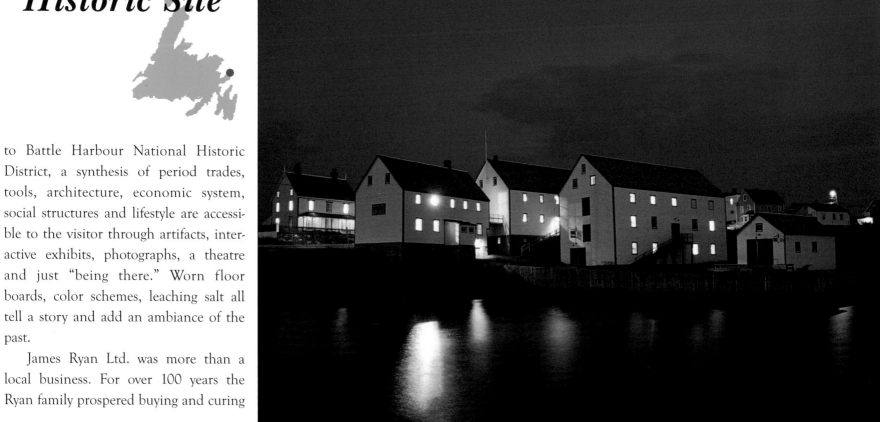

Waterfront view of James Ryan Ltd. Mercantile Premises.

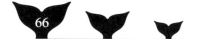

salt cod, selling it all over the world with markets in Portugal, Spain, Italy and the West Indies.

Like other merchants of his time James Ryan Ltd. business enterprises went beyond the inshore fishery. The merchant economy of the day extended to general merchandising and other economic pursuits...anything to make a dollar – ultimately creating an economic empire.

The merchant economy which was non monetary, saw the fisherman almost always indebted to the merchant. The relationship between the fisherman and merchant was a barter of food and supplies in exchange for the fish the fisherman caught, split and dried. The merchant setting the price for the fish kept him in control of the fisherman ... the fisherman was dependant upon the merchant for credit and ultimately his survival.

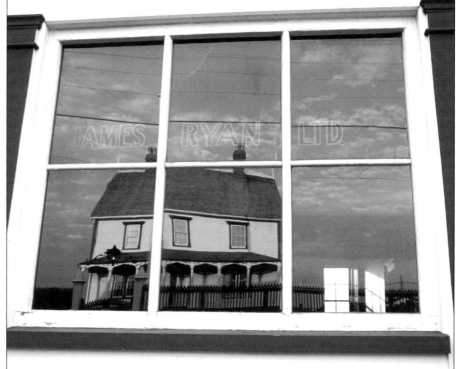

Morning moon over Proprietor's house.

Window pane of the manager's office reflects daytime frontal view of Proprietor's house.

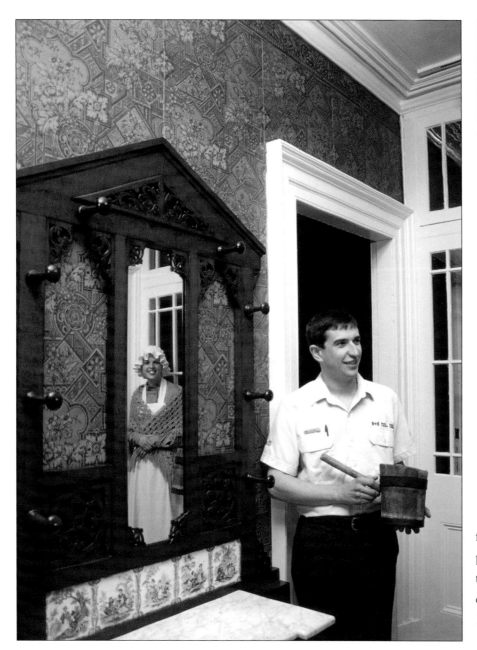

Paul, a Parks Canada guide, shows a "Piggin" (traditional boat bailer) to Shannon, dressed as the proprietor's domestic servant "Flora."

The General Store was not only the primary source of provisions and supplies but served as an important social gathering place. The "credit card" of years gone was known as the "Barter, Credit or Truck" system. The merchant in many traditional isolated outport communities was somewhat similar to the modern day bank ... many people in the community were dependant upon the merchant and their credit.

The invention of refrigeration, a rapidly developing fresh and fresh-frozen fish trade led to a collapse of the traditional salt fish in 1952 and profoundly affected James Ryan Ltd. affairs. Moving out of the fish trade, the firm diversified to a wholesale and retail distributor, selling everything from groceries to furniture, before finally closing its doors in 1978.

"Sweet the breath of morn ... pleasant the sun, when first on this delightful land he spreads his orient beams."

John Milton

astle Hill National Historic Park preserves the relics of French and English fortifications built in the seventeenth and eighteenth centuries. Placentia (known as "Plaisance" to the French) attracted fishermen for a variety of reasons, not the least of which was its protected harbour and pebble beach, which was ideal for drying cod. French fishermen first arrived in Placentia early in the mid to late fifteenth century founding their first official colony in 1662.

Placentia was a strategic location for the French. It served three main functions: to check potential English expansion in Newfoundland; as a base from which to defend the approach to Canada in wartime; and as a protective base for the French fishing fleet in Newfoundland.

Castle Hill National Historic Site

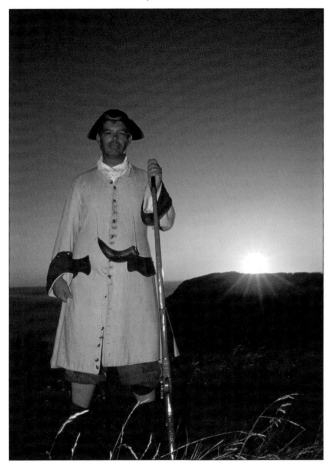

Sentry at sunset.

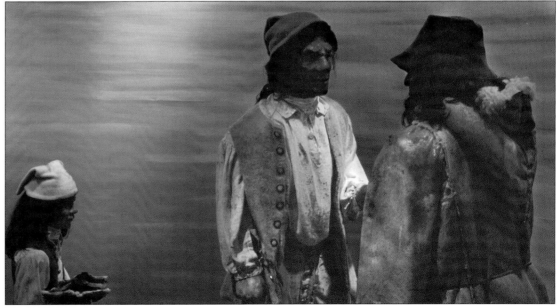

Child carries saltfish; Interpretation display with French settlers in period costume.

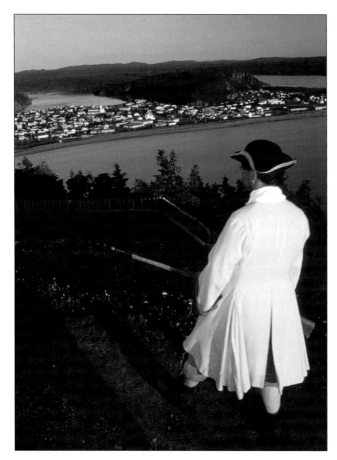

Marching the perimeter of Fort Royal.

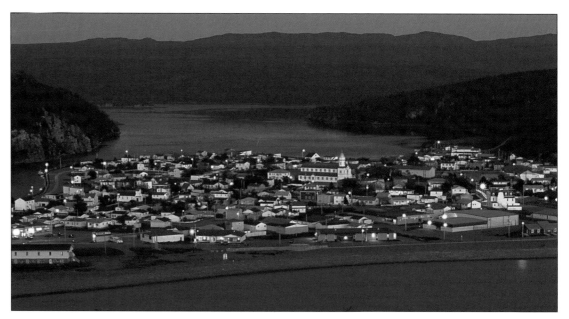

Town of Placentia today. This low lying pebbled beach was ideal for drying codfish.

Sentry on top of reminants of Fort Royal.

The most important hilltop fortification, Fort Royal, was started on Castle Hill in 1693 but not completely finished until around 1702. Fort Royal's mountainous position was virtually inaccessible to an enemy and offered a panoramic view of the town.

One major limitation of the French in Placentia was their dependance on imported foodstuffs from France, Canada, and New England. As a result enemy blockades across the mouth of Placentia Bay occasion-

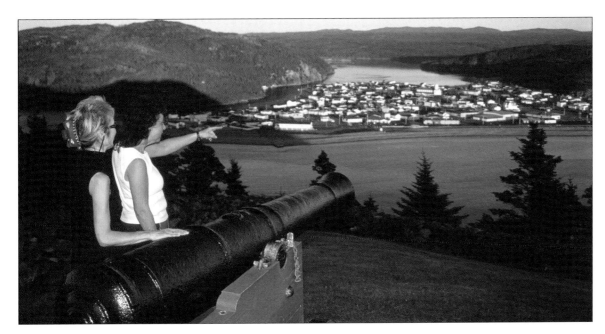

ally led to famine in Plaisance. With low morale among a declining population the colony was ceded to the British by the Treaty of Utrecht in 1713.

Taking possession of the former French colony the British renamed it Placentia. An integral component of the French and English fortifications, Castle Hill became a National Historic Site in 1968.

⟵ *Period cannon overlooking the bay and town, once used to defend Fort Royal.*

The foundation of Fort Royal is approximately one metre think. Beyond the foundation is a well-manicured walk that was reached only by the best and hardy and fortunate attacking soldiers. ⟶

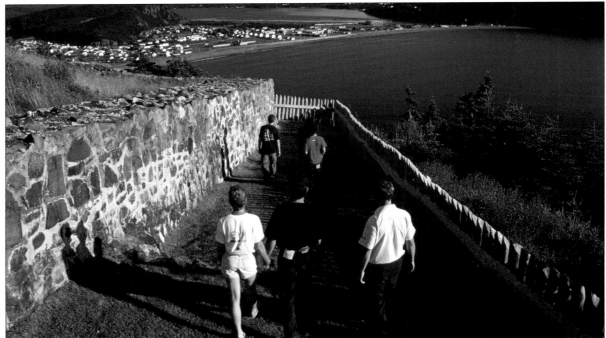

Hawthorne Cottage National Historic Site

"But the sea is a different sort of enemy. Unlike the land, where courage and simple will to endure can often see a man through; the struggle against the sea is an act of physical combat, and there is no escape. It is a battle against a tireless enemy in which man never wins; the most that he can hope for is not to be defeated."

Alfred Lansing

Over the past 500 years Newfoundlanders have developed a reputation as a seafaring people. The fact that some would rise to international stature should not be surprising. Captain Robert A. Bartlett is one such individual. Bartlett is most famous for his work as Peary's navigator in his journeys to the North Pole. Bartlett's other arctic exploration work included: The National Geographic, the Smithsonian, and a variety of other scientific groups elevating him to icon status for his contribution to the history of arctic exploration.

Hawthorne Cottage was the Brigus home of Captain Bartlett. Its life line has one parallel with the captain and that is not always being in one place.

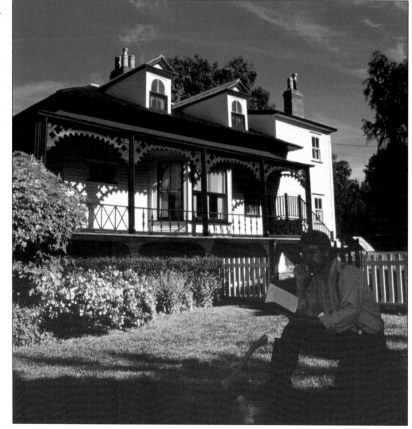

"West wing" of Hawthorne Cottage. In the shadow is local actor Lloyd Pike reading a journal entry of Captain Bob Bartlett.

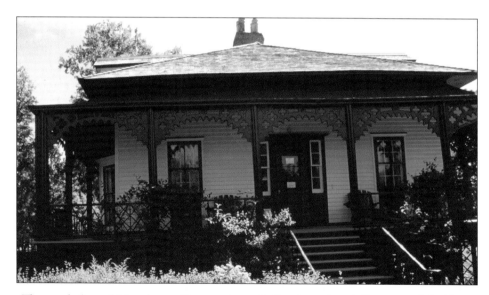

The north face of Hawthorne Cottage, beautifully adorned with flowers and shubbery.

Originally constructed further inland in the community of Cochrandale, in the winter of 1834, it was moved ten kilometres on rollers to its present site in the coastal community of Brigus. Bartlett's affinity to Hawthorne cottage lasted into adulthood. He frequently stopped in on return voyages from the arctic dropping off mementos, many of which are on display throughout the home today.

Both the historical significance of Captain Bob Bartlett's work and the architectural quality of Hawthorne Cottage have been recognized by the Historic Sites and Monuments Board of Canada.

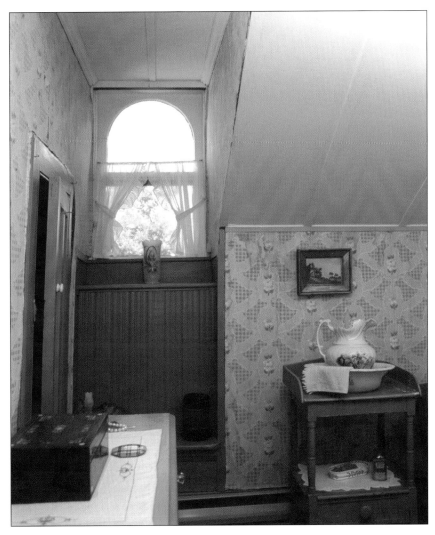

Period furniture including traditional wash basin and water jug used prior to running water.

The dining room including period newspapers featuring the famous captain.

"Animals are such agreeable friends. They ask no questions, the pass no criticisms."

George Eliot

Salmonier Nature Park

Salmonier Nature Park was established in 1978. Its primary role is educating visitors about wildlife and their environment. In the process of fulfilling this mandate the park has emerged as a tourist destination, wildlife rehabilitation, research and environmental monitoring. Within the forty hectare developed portion of the park, eighty-four species of birds, fifteen species of mammals and over 170 species of vascular plants have been recorded.

The three kilometre boardwalk trail passes some fourteen (subject to change) natural habitat enclosures designed to balance animal needs with visitors' viewing expectations. Most of the animals in the park are products of the parks involvement in the

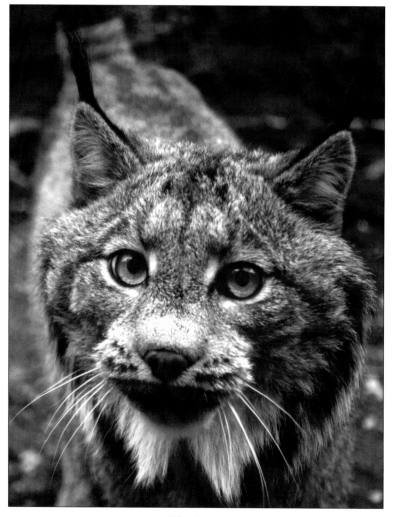

The Lynx.

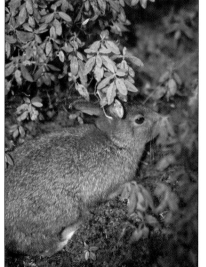

A Snowshow Hare, introduced from Nova Scotia in 1864 and 1876.

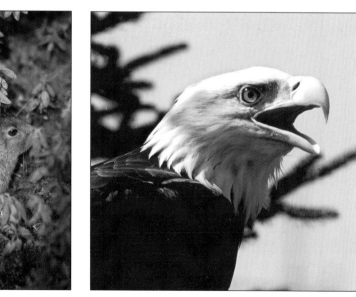

A mature Bald Eagle with an 8-foot wing span.

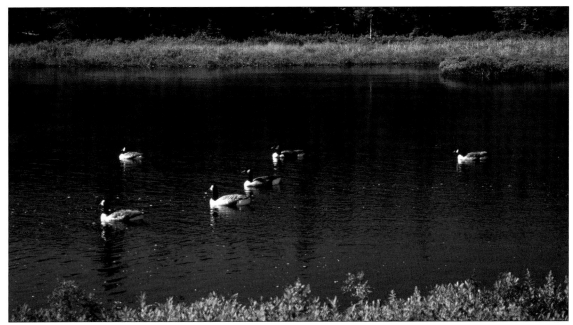

Canada Geese.

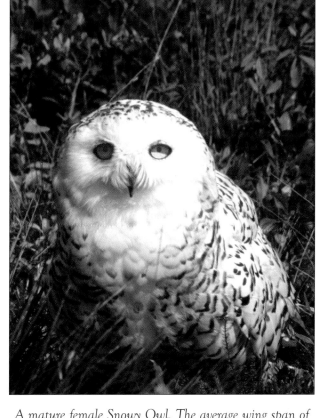

Provincial Rehabilitation Program for injured and orphaned animals. Many of the wildlife in this program that cannot be released back to the wild stay at the park or are released to a similar facility.

In addition to its education programs, Salmonier Nature Park has been developing expertise in captive breeding of the endangered Pine Martin as part of the Newfoundland Marten Recovery Plan. A state-of-the-art enclosure for the captive breeding of Newfoundland marten saw its first captive bred litter born in 1999. A remote video monitoring system allows animal care staff and visitors to view this unique and endangered species with a minimum of human disturbance to the animals.

A mature female Snowy Owl. The average wing span of the snowy owl is approximately 5 feet.

The Park is quite different from people's perception of a zoological park. The overall design and broad environmental education mandate sets Salmonier Nature Park apart from most similar facilities.

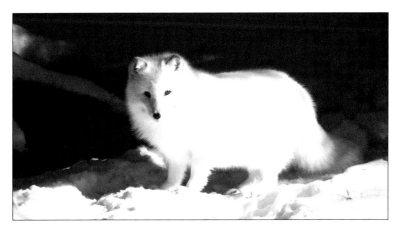

Arctic Fox's winter coat.

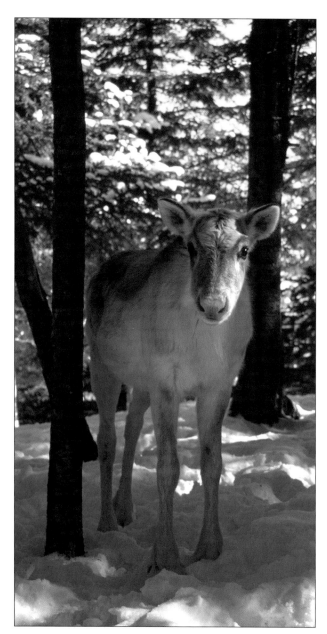

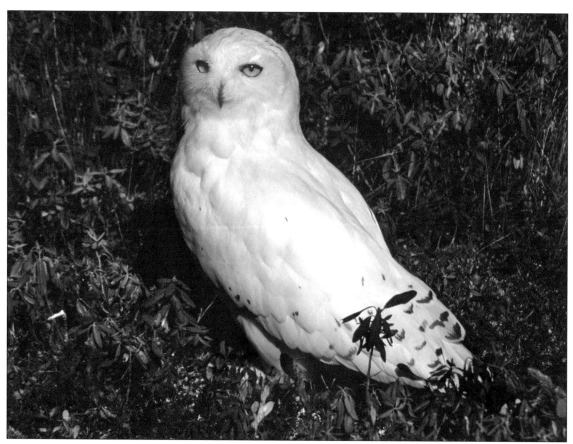

A mature male Snowy Owl. These birds can swivel there heads up to 270 degrees and have been known to raid traditional trap lines with regularity.

The 1949 Newfoundland postage stamp featured the caribou with the caption "Monarchs of the Wild." Deer Lake, located on the province's west coast was named after the deer (caribou) that regularly swam across the lake. Today Newfoundland and Labrador is home to both the woodland caribou and the barren ground caribou species. The George River herd of Northern Labrador is the largest caribou herd in the world etimated at between 500,000 and 700,000 animals.

"So fades a summer cloud away; So sinks the gale when the storms are o'er; So gently shuts the eye of day; So dies a wave along the shore."

Anna Letitia Barbauld

East Coast Trail

The East Coast Trail has it all. Eighteen routes totaling over 220 kilometres can be done independently or linked for extended trips. Clinging to the rugged shores of North America's most easterly edge between Cappahayden and Cape St. Francis, the East Coast Trail traverses: provincial parks, national historic sites, ecological reserves, wilderness areas, archeological digs, resettled communities, lighthouses, the Spout (a wave induced geyser), icebergs and a wide variety of natural history.

Most of the trail, a composite of wilderness boreal forest and exposed barrens, offers frequent and spectacular panoramic scenic vistas of Newfoundland's coast and the sea. Often referred to as the "Graveyard of the Atlantic," Newfoundland's east coast is world renowned for the

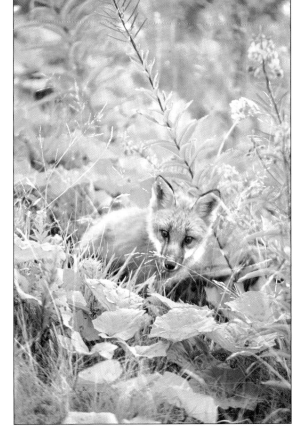

A red fox along the trail

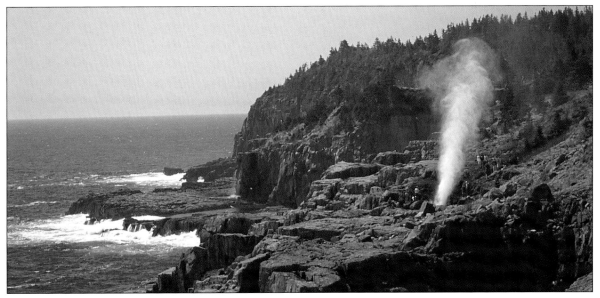

The spout blows mist 20-60 feet skyward. This has served as a navigational landmark for the last 500 years.

number of shipwrecks off its shores. The resettled community of La Manche is a grim reminder of the respect owing the earth's natural phenomena and its ultimate authority. On January 28, 1966, a tidal wave struck the community washing away all the flakes, boats, stores, suspension bridge connecting both sides of the harbour and demolishing most of the homes. It was a miracle no one died. The resettled community of Freshwater is interesting as it represents the traditional secular divisions that existed among coastal communities for hundreds of years. The Anglicans that were refused land in Bay Bulls by the Catholics moved a

A 200-foot sea stack with bald eagle nest visible to passing hikers.

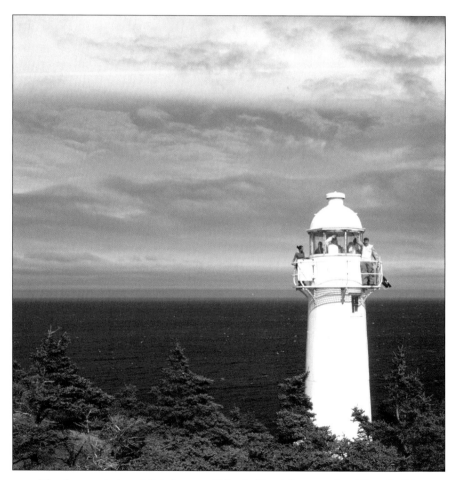

The decommissioned lighthouse of North Head (just north of Bay Bulls).

ways down the coast establishing their own nearby community of Freshwater.

Already on the world map of distinguished hiking trails, the East Coast Trail is in the process of being further developed to include an additional 300 kilometres of coastal routes.

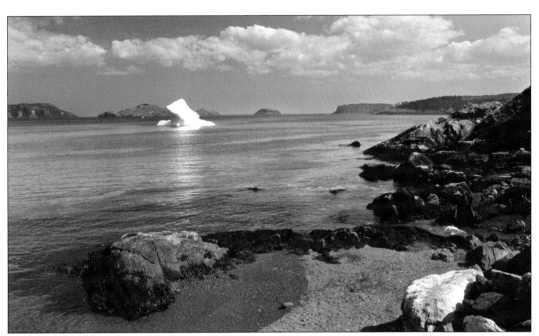

A grounded iceberg near Tors Cove.

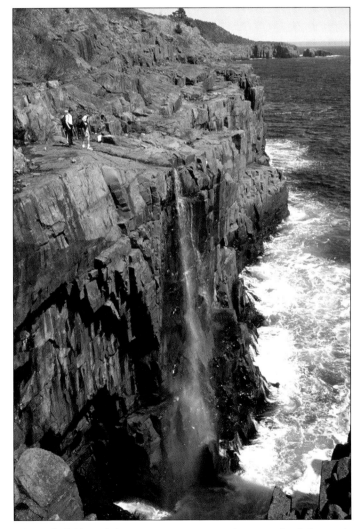

Vertical cliffs and dramatic viewscapes adorn much of the trail.

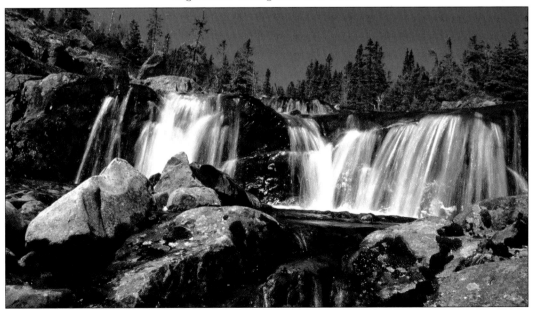

Waterfall near the spout.

Signal Hill National Historic Site/St. John's

Cabot Tower is the most popular attraction in Signal Hill National Historic Park. Cabot Tower was built between 1898 and 1900 to commemorate the 400th anniversary of John Cabot's 1497 voyage of discovery and Queen Victoria's Diamond Jubilee.

In 1901, Marconi received the first trans-Atlantic wireless signal at a position near Cabot Tower. He received the letter "S" in Morse Code which was sent from Cornwall, England ultimately leading to the development of the modern day radio and other electronic gadgetry.

From Signal Hill, visitors have a panoramic view of the city of St. John's and environs. Walking trails throughout the park offer daring views of the city, the harbour, and the ocean. The elevated granite domes in the park are not as high as the Rocky Mountains but they are older and adjacent to the ocean.

St. John's and Signal Hill were the site of numerous hostilities. One of the highlights on Signal Hill each summer is the re-enactment of the nineteenth century British military muscle that includes the clap of the cannon, mortars and musket fire, combined with moving melodies of

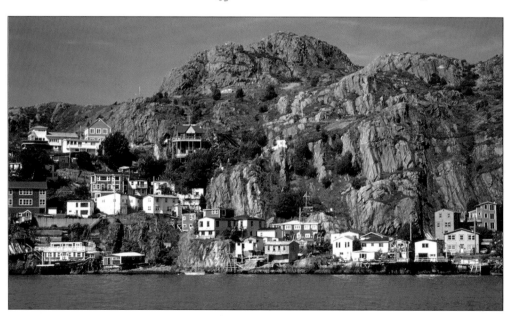

"Jelly Bean Row." The outer battery located on the north shore of the St. John's harbour entrance.

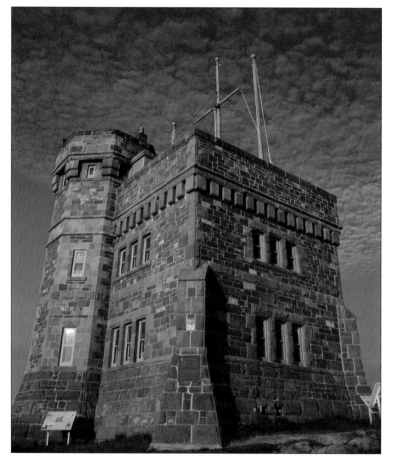

Cabot Tower, a historic St. John's landmark for the past century.

Performance of Signal Hill Tatoo.

the Fife and Drum Band — an internationally renowned award winning historical performance program suitable for a kid and king alike.

Signal Hill National Historic Park is a signature site for any visitor.

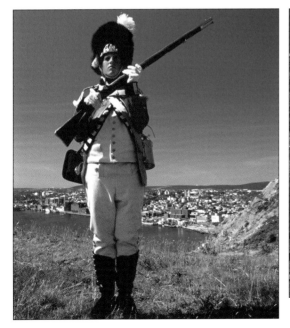

Sentry stands guard over modern St. John's.

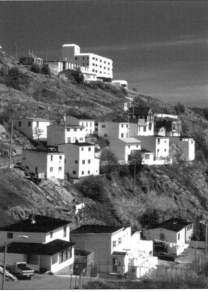

Houses stacked on the steep hillside of the battery.

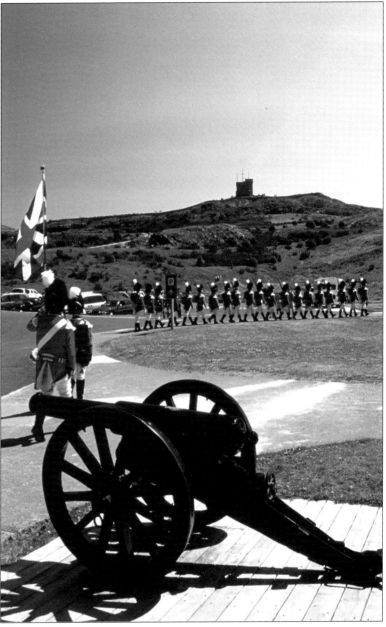

Soldiers make their way to their barracks after a Signal Hill Tatoo performance. Note: Cabot Tower in background.

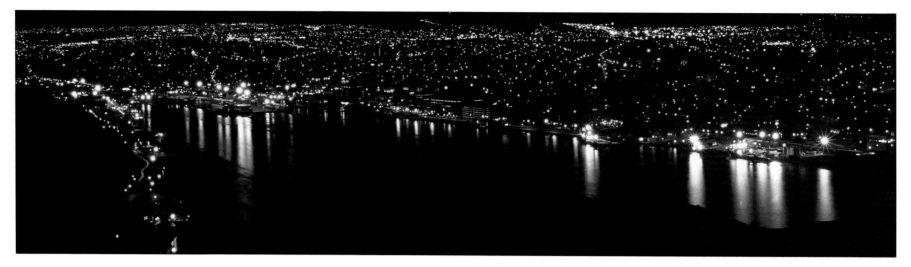

Night view of St. John's Harbour from Sigmal Hill.

Traditional St. John's row housing.

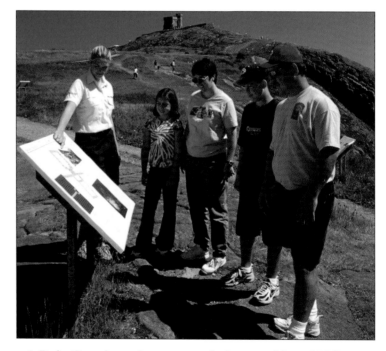

A Parks Canada guide interprets the history of Signal Hill to a visiting family.

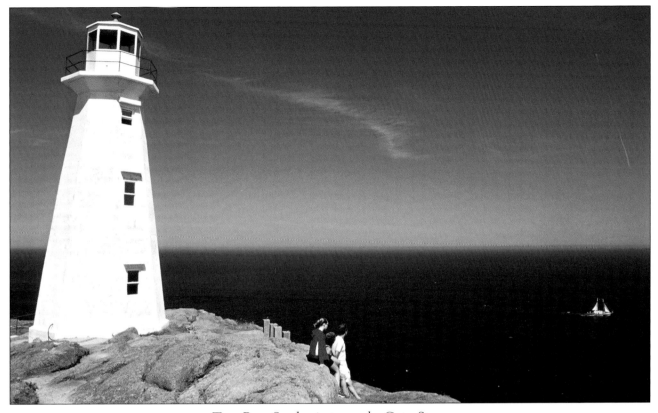

Tour Boat Scademia passes by Cape Spear.

Cape Spear National Historic Site

Cape Spear National Historic Site is the most easterly point of land in Newfoundland and Labrador. When you stand at Cape Spear you are closer to the west coast of Ireland than you are to Thunder Bay, Ontario. The two lighthouses at Cape Spear today represent the old and the new. The two story wooden structure is the oldest existing lighthouse in Newfoundland. Built in 1835 it was the marine beacon until 1955. It is now a museum offering a glimpse of the light keeper's life for that period. The newer automated lighthouse is conical in shape.

Believe it or not World War II did touch the east coast of North America. In order to protect this part of the coast, two gun emplacements, underground passages, bunkers and barracks were constructed at Cape Spear. Remnants of the gun emplacements and bunkers remain today.

The elevated open barrens of Cape Spear National Historic Site are ideal for hiking and whale watching. Just south of Cape Spear, the Witless Bay Ecological Reserve boasts the highest summer concentration of humpback whales in the world. Many whales migrating in search of, or following food sources, pass close by the site's shoreline.

Panels depicting Whales that migrate past Cape Spear.

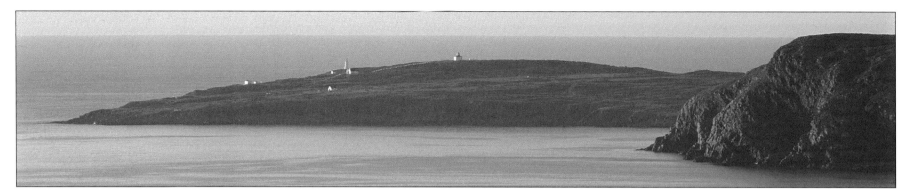

View of Cape Spear from Signal Hill

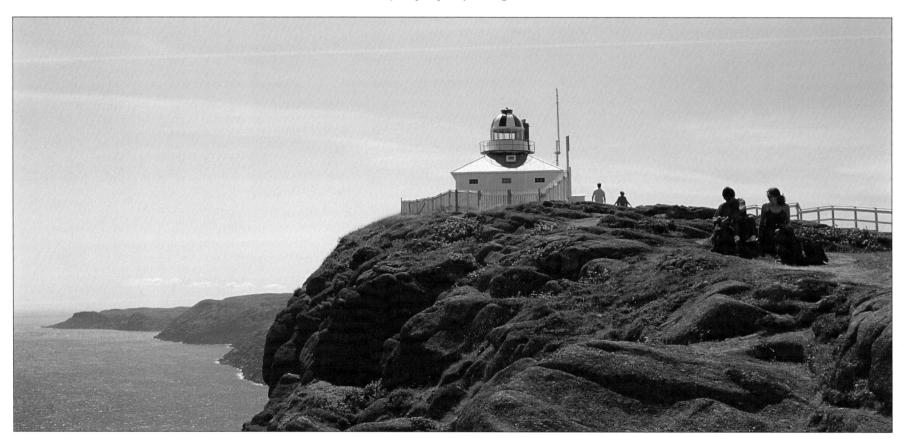

Newfoundland's oldest existing lighthouse dating back to 1835.

The Witless Bay Ecological Reserve which consists of four islands and the waters around them, is home to a phenomenal number of seabirds. It boasts North America's largest colony of Black-legged kittiwakes and Atlantic puffins, as well as the world's second largest colony of Leach's storm petrels and common murres. The site also hosts Razorbill Auks, Great Black-backed Gulls, Northern Fulmars, Black Guillemots, Common and Thick-billed murres.

The Puffin's protection from marauding gulls lies in their ability to burrow deep into a thick layer of humus on the hillside. In their quest for food their flight take-off from the elevated hillside is simple when compared to their take-off from the water with the encumbrance of their newly acquired cargo of fish. The puffins run and skip along the top of the water trying to get airborne. Once airborne, the puffins run the gauntlet of greedy gulls, ready to attack without provocation when a meal is at stake. With thousands of birds flying overhead, a wide brimmed hat is an essential part of one's dress.

The world's largest summer concentration of humpback whales occurs in Witless Bay Ecological Reserve. In addition to the humpback, Minke whales are also common in summer. Like the birds, they are attracted by the profuse caplin and fish stocks. Visiting the reserve is a sensory experience. On a recent sea kayak trip I felt completely surrounded. Birds flew continuously overhead; a monstrous iceberg was grounded in 200 feet of water; a humpback whale "breached" (completely jumped out of the water) eight

Witless Bay Ecological Reserve

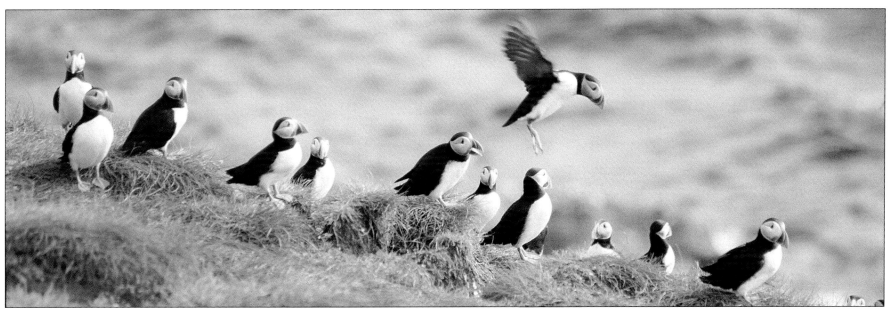

Puffins - Strength in numbers help keep marauding Black-backed Gulls at bay.

times to the delight of a near-by tour boat loaded with whale watch clientele. A short time later three humpbacks traveling side by side swam towards me. As they reached my position, one whale swam beneath my kayak as the other two whales simultaneously surfaced, one on each side just meters from my kayak. For a softer adventure a variety of tour boat operators offer tours of the reserve and environs.

← *Hillside filled with Puffin burrows. An immense volume of bird scat with high acidic levels limit vegetation.*

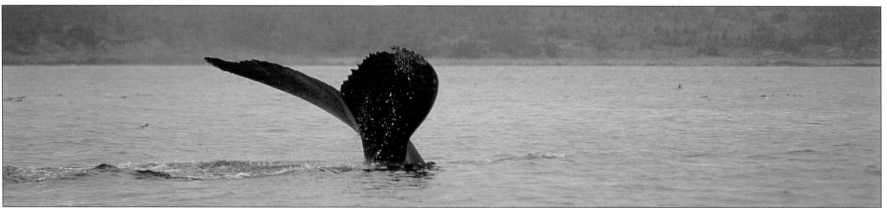

Humpback Whale making a dive after a breath of fresh air.

The Puffin - sometimes referred to by some as the Newfoundland Parrot

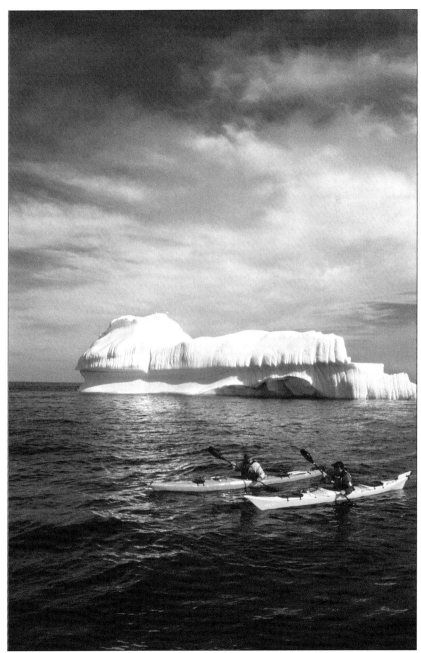

Passing an iceberg grounded in 200 feet (70 metres) of water.

Mistaken Point Ecological Reserve

"Adopt the secret of nature: her secret is patience."

R.W. Emerson

The Mistaken Point Fossil Assemblage comprise 565 to 575 million years old marine organisms – the oldest complex (multicellular) life on earth and the only deep-water marine fossils of this age found anywhere. Normally when an organism is fossilized, only the hard parts are preserved (ie. shell, bone). Mistaken Point is an atypical fossil site as all of its fossils are of soft bodied creatures. The creatures died in place after they were buried by volcanic ash and dust. The volcanic ash is obvious at most of the fossiliferous levels. Possible modern relatives of the mistaken point fossils include jellyfish and sea anemones.

Additional discoveries of complex fossils resulted in the extension of Mistaken Point Ecological Reserve. They are the oldest, large, architecturally complex fossils known anywhere. These fossils, including the recently discovered "pizza fossil" provide a new focus, attracting an international mix of paleontologists. Efforts to recognize Mistaken Point as a UNESCO World Heritage Site are ongoing.

A visit to Mistaken Point is suitably close to the Cape Race lighthouse. Cape Race is famous for being the first to receive the *Titanic*'s distress call.

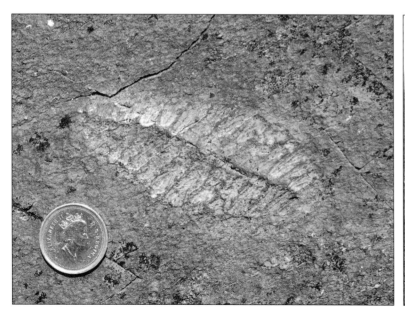

Mistaken Point's most common fossil, The Spindle.

Piles of rock along the trail were once used for drying fish.

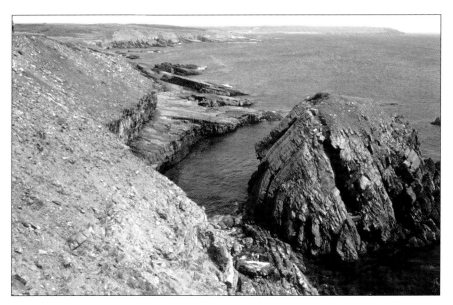

Looking toward Cape Race from Mistaken Point Trail.

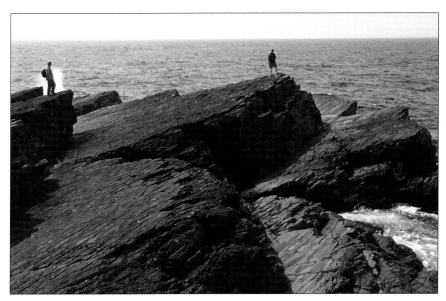

Shallow dipping sedimentary units and features at Mistaken Point.

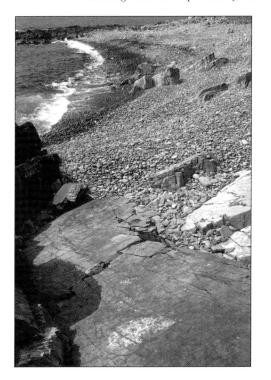

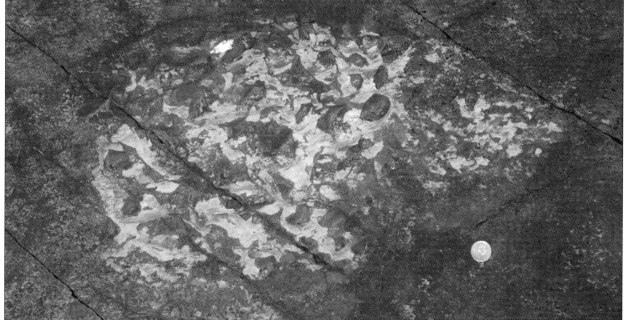

Left: in situ pizza fossil. Above: close-up view of pizza fossil, approximate size, large to jumbo. ☺

"Ever charming, ever new, when will the landscape tire the view?"

John Dyer

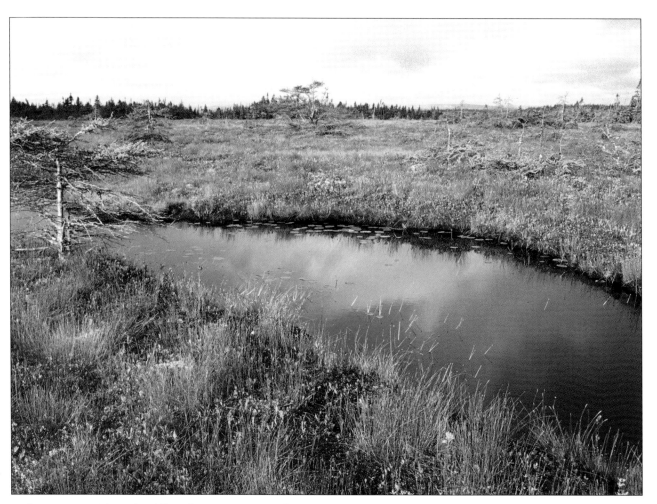

Avalon Wilderness Reserve

Protecting the unique Avalon caribou herd was the primary intent in establishing the Avalon Wilderness Reserve. The Avalon caribou herd represents the most southerly range of woodland caribou in North America and possibly the world. Through illegal hunting the Avalon Caribou Herd's population receded to 1,000 before rebounding to the current 5,500. No where in North America is there a herd this large as close to major populations as on the Avalon Peninsula.

The Avalon Wilderness Reserve represents one of North America's most accessible unspoiled wilderness spaces. It is a gently rolling plateau with gigantic glacial erratics left by the receding Laurentide glacier over 10,000 years ago. The Avalon is one of the few places in the world with evidence of the 600 million-year old Precambrian ice age. Dominated by peatland, barrens, heaths, dwarf spruce and fir, locally referred to as

Latter stages of pond infilling, bog supports a wide variety of plants especially the carnivorous pitcher and sundew.

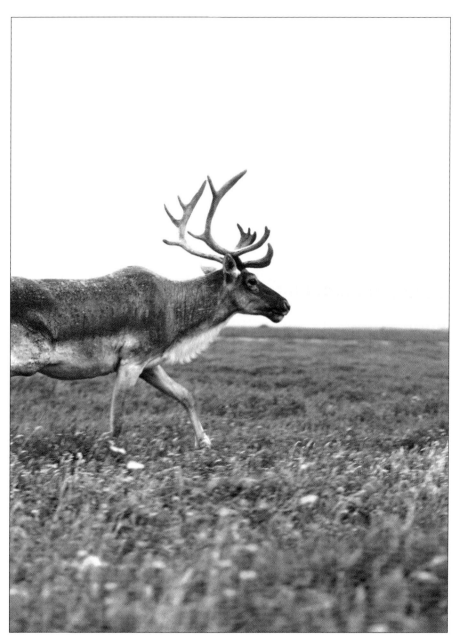

"tuckamore," the countryside is relatively open except for ravines and valleys that offer protection from the elements, allowing trees to grow normally to average heights and density.

Among the flora found in the Avalon Wilderness Reserve is the pitcher plant, Newfoundiand's floral emblem. Normally found in bogs this carnivorous plant's cup-shaped leaves are lined with downward pointing hairs, keeping insects from escaping. Once trapped in the water-filled,

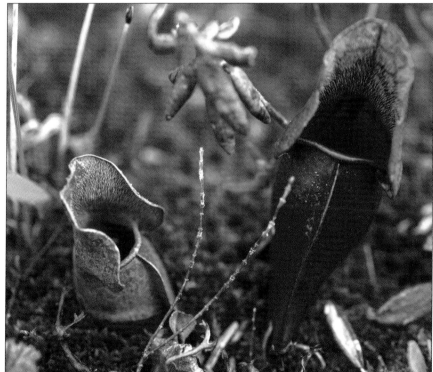

A mature Caribou Stag grazes in the Avalon Wilderness Area. A recent outbreak of brain worm disease has depleted the Avalon Wilderness Area's Caribou herd.

The young and the old pitchers of a pitcher plant that contain liquid enzymes to decompose and ultimately consume any insect landing inside.

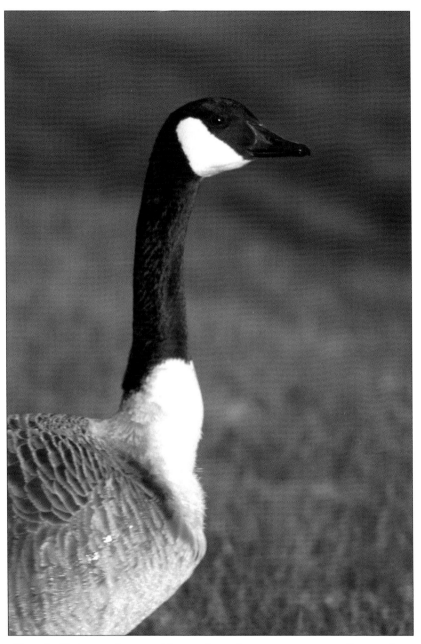

enzyme rich reservoirs, the insects die and decompose only for the nutrients to be absorbed by the plant.

Moose are not native to insular Newfoundland. An unsuccessful introduction in 1878 and successfully introduced in 1904, the first moose to appear on the Avalon was in the 1940s. Today the Avalon Wilderness Reserve supports a population of approximately 3,500 Moose.

Other mammals found in the reserve are typical of most areas of Newfoundland and include lynx, fox, snowshoe hare, otter, beaver, muskrat, weasel, mink, red squirrel, shrew and meadow vole. Waterfowl include the Canada goose, black duck, northern pintail, greenwinged teal, ring-necked duck, common golden eye as well as common and red-breasted merganser. The Reserve boasts the highest density of Canada geese on the Island.

Canada Geese weigh up to 12 pounds, with a wingspan normally exceeding one metre.

Snowshoe Hare and Ruffed Grouse seeking similar shelter and food sources.

"The pleasantest things in the world are pleasant thoughts: and the great art of life is to have as many of them as possible."

Montaigne

Cape St. Mary's Ecological Reserve

Cape St. Mary's Ecological Reserve is the most accessible and second largest Northern Gannet colony in Eastern North America. "Bird Rock," the primary nesting site, is an elevated sea stack separated from the mainland by a mere fifteen metres, offering visitors an intimate but nonintrusive view of courtship, nesting and rearing behaviors. Some world-renowned ornithologists have likened the intimacy of the Cape St.

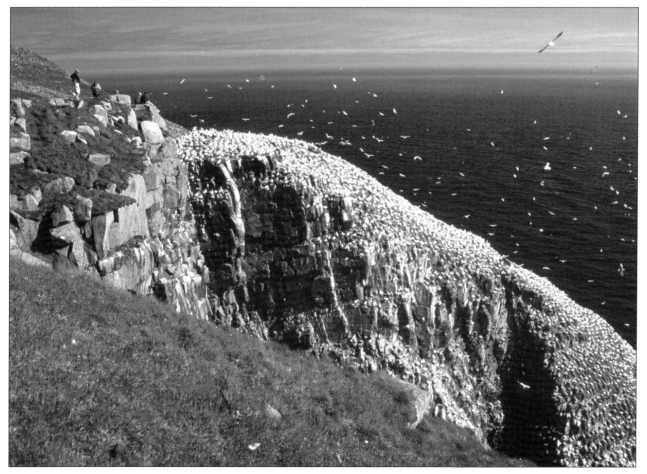

Infamous Bird Rock... Birders look down upon the Colony dwarfed by its sheer size.

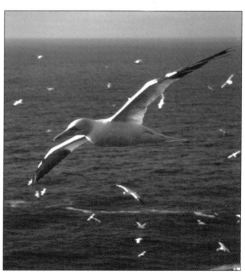

Northern Gannets in flight.

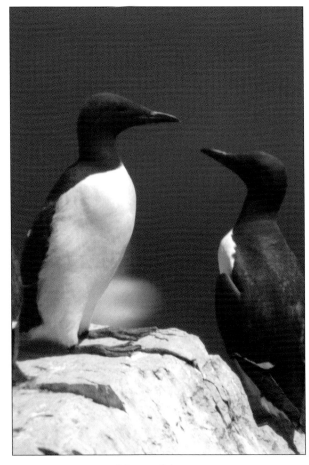

Nesting Murres.

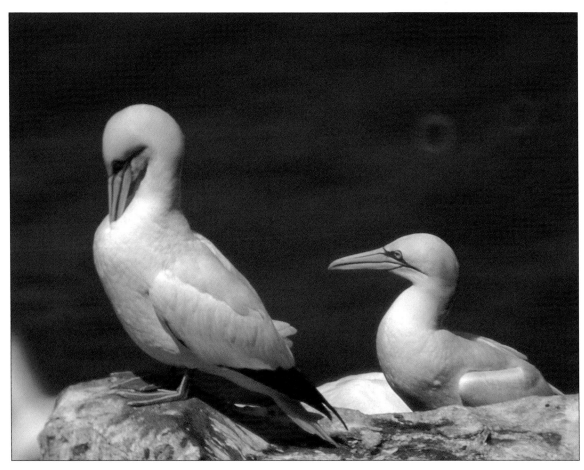

Nesting Northern Gannets.

Mary's experience as "...the birds swirl past the cliffs like a blizzard of snow!"

In addition to Northern Gannets, "The Cape" hosts nesting Common Murres, black legged kittiwakes, Razor Bills, Black Guillemot, and the world's most southerly nesting colony of thick-billed murres.

The fifteen to thirty minute walk between the interpretation center and Bird Rock on an elevated headland 130 metres above sea level offers an ideal opportunity for shore based whale watching. Schools of spawning and migrating fish attract whales to this coast and easily sustain over 30,000 breeding pairs of birds.

During the summer breeding season Cape St. Mary's Ecological Reserve is a popular attraction, drawing tens of thousands of visitors. An interpretation center, reserve naturalist, and arctic alpine vegetation, supplement and support the birding spectacle.

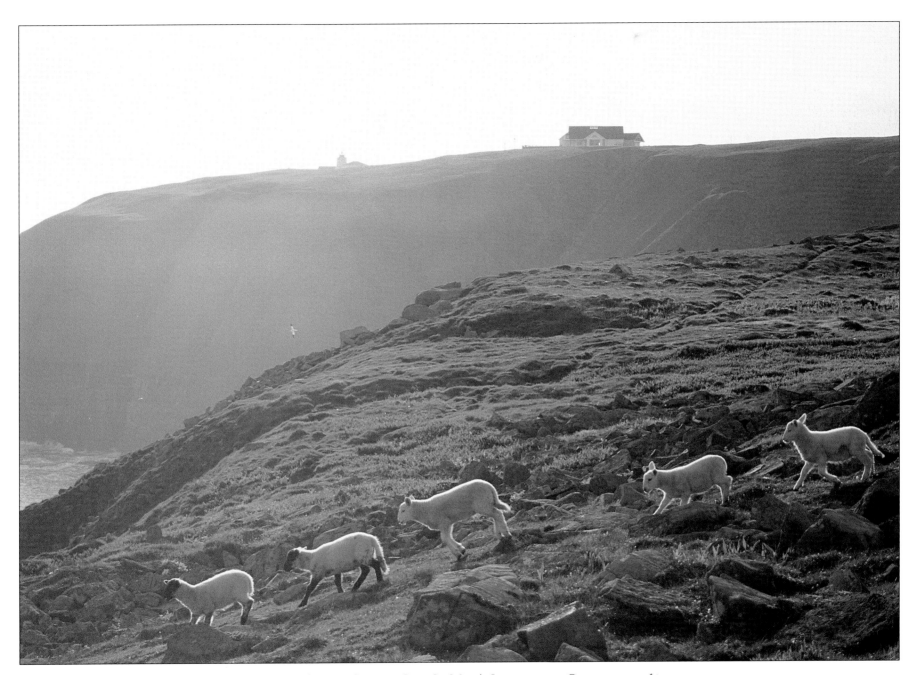

Free-roaming sheep at the cape, Cape St. Mary's Interpretation Centre at top of image.

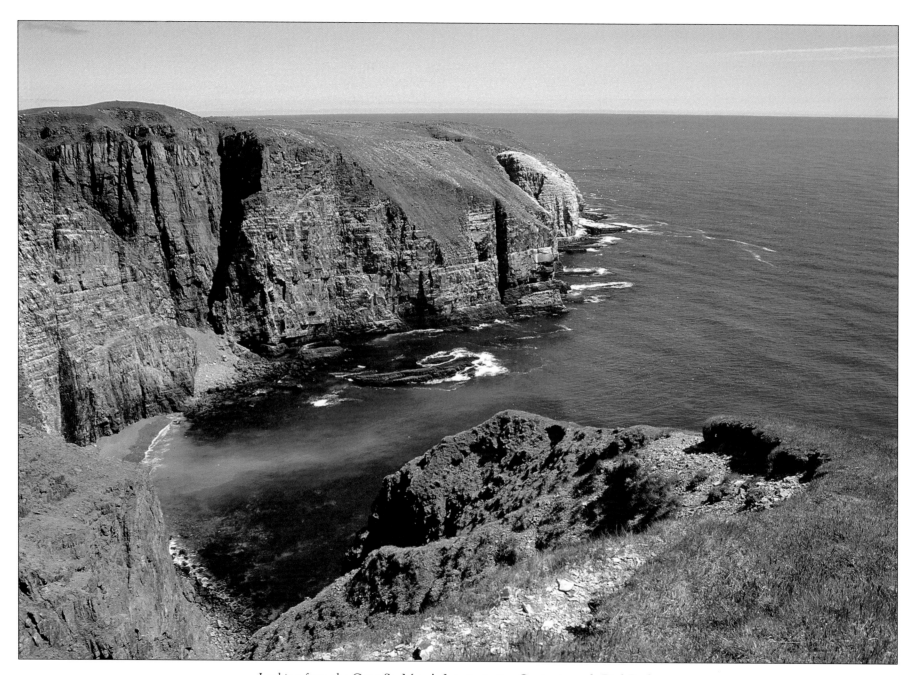

Looking from the Cape St. Mary's Interpretation Centre towards Bird Rock.

ODE TO NEWFOUNDLAND

When sun rays crown thy pine clad hills,
And summer spreads her hand,
When silvern voices tune thy rills,
We love thee smiling land,
We love thee, we love thee
We love thee smiling land.

When spreads thy cloak of shimm'ring white,
At winter's stern command,
Thro' shortened day and starlit night,
We love thee frozen land,
We love thee, we love thee,
We love thee frozen land.

When blinding storm gusts fret thy shore,
And wild waves lash thy strand,
Thro' sprindrift swirl and tempest roar,
We love thee windswept land,
We love thee, we love thee,
We love thee windswept land.

As loved our fathers, so we love,
Where once they stood we stand,
Their prayer we raise to heav'n above,
God guard thee, Newfoundland,
God guard thee, God guard thee,
God guard thee, Newfoundland.

ODE TO LABRADOR

Dear land of mountains, woods and snow,
Labrador, our Labrador.
God's noble gift to us below,
Labrador, our Labrador.
Thy proud resources waiting still,
Their splendid task will soon fulfill,
Obedient to thy Maker's will,
Labrador, our Labrador

Thy stately forests soon shall ring,
Labrador, our Labrador.
Responsive to the woodsman's swing,
Labrador, our Labrador.

And mighty floods that long remained,
Their raging fury unrestrained,
Shall serve the purpose God ordained,
Labrador, our Labrador.

We love to climb thy mountains steep,
Labrador, our Labrador.
And paddle on thy waters deep,
Labrador, our Labrador.
Our snowshoes scar thy trackless plains,
We seek no city streets nor lanes,
We are thy sons while life remains,
Labrador, our Labrador.

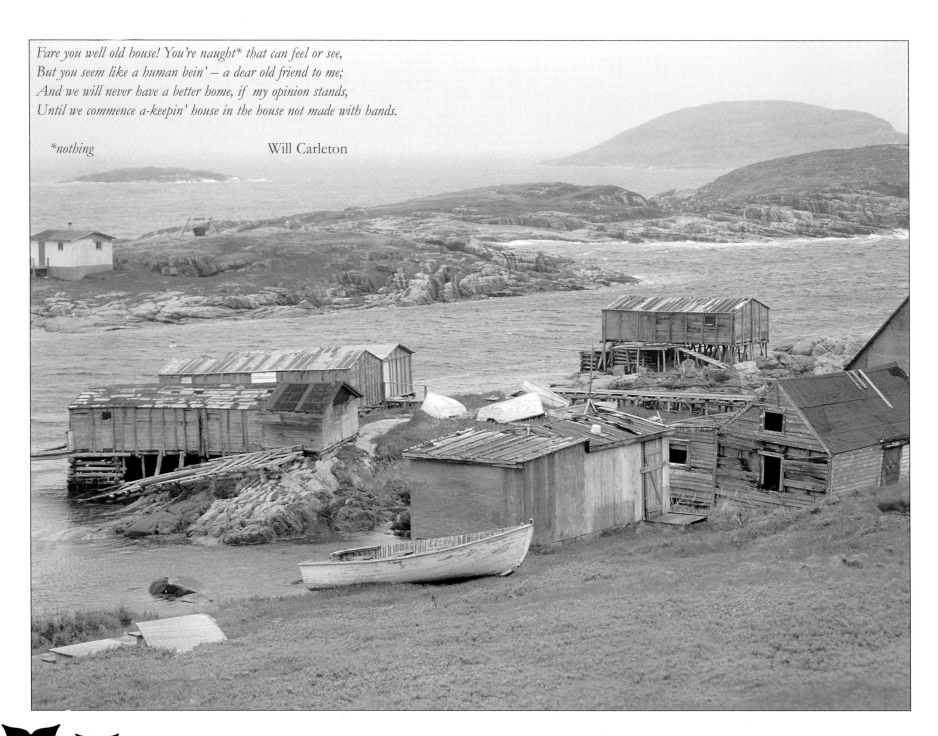

Fare you well old house! You're naught* that can feel or see,
But you seem like a human bein' – a dear old friend to me;
And we will never have a better home, if my opinion stands,
Until we commence a-keepin' house in the house not made with hands.

*nothing Will Carleton